Marine Life Patterns
for the Scroll Saw

by Dale Terrian

Fox
Chapel Publishing Co. Inc.

1970 Broad Street • East Petersburg, PA 17520 • www.foxchapelpublishing.com

Marine Life Patterns for the Scroll Saw is a brand new work, first published in 2002 by Fox Chapel Publishing Company, Inc. The patterns contained herein are copyrighted by the author. Artists purchasing this book have permission to make up to 200 cutouts of each individual pattern. Persons or companies wishing to make more than 200 cutouts must notify the author in writing for permission. The patterns themselves, however, are not to be duplicated for resale or distribution under any circumstances.

Publisher	Alan Giagnocavo
Editor	Ayleen Stellhorn
Desktop Specialist	Linda L. Eberly, Eberly Designs Inc.
Cover Design and Photography	Tim Mize

ISBN 1–56523–167–8
Library of Congress Card Number: 2001119965

To order your copy of this book,
please remit the cover price
plus $3 shipping to:
Fox Chapel Publishing Company
Book Orders
1970 Broad Street
East Petersburg, PA 17520

Or visit us on the web at
www.foxchapelpublishing.com

Printed in China
10 9 8 7 6 5 4 3 2 1

Because working with a scroll saw inherently includes the risk of injury and damage, this book carries no guarantee that creating the projects described herein is safe for everyone. For this reason, this book is sold without warranties or guarantees of any kind, express or implied, and the publisher and author disclaim any liability for any injuries, losses or damages caused in any way by the content of this book or the reader's use of the tools needed to complete the projects presented herein. The publisher and the author urge all scrollers to thoroughly review each project and to understand the use of any tools involved before beginning any project.

Table of Contents

About the Author

Dale Terrian has had a self-described "love affair" with wood since he was a child. His first project was a whistle, carved from a willow branch with a penknife. From there, he moved on to cars, animals, and whatever else he could coax out of the scrap wood he found.

Later in life, carving was put on hold for a lot of things, including "girls, jobs and family, in that order." Dale worked in construction, so most of his carving took place during the winter months when work was slow and layoffs were frequent. He tried his hand at more ambitious, time-consuming projects, including a bedroom set and a full-size pool table.

When Dale retired, he took up carving again. This time it was fish. His first efforts were "a bit crude," but they were good enough to appease his fisherman father-in-law, who often let Dale carve instead of insisting that he spend quality family time in search of the elusive fish that got away. Soon Dale found himself attending carving shows and entering his own work into competition. As he won more ribbons, his wife, Ruth, suggested that he try to sell some of the carved fish.

A couple local art galleries agreed to sell Dale's work. Unfortunately, as many decorative carvers discover, the sale price for a realistic carving can quickly surpass that which a buyer is willing to spend. One gallery owner suggested that Dale find a way to apply his talents to quality pieces that didn't require as much time or materials costs. After tossing the idea around in his head for a while, Dale hit on the idea to scroll saw his sculptures.

Dale Terrian

Today, Dale does a brisk business selling his scroll sawed pieces to individuals and businesses near his Lady Lake, Florida, home. The majority of his pieces are oversized, called "Wall Sculptures," and are designed to fill empty expanses of wall not otherwise suited to windows, mirrors or framed artwork. Inquiries about finished pieces of art for sale can be e-mailed to Dale at *rdterrian@aol.com*.

Before You Begin

Recommended Tools and Materials

Scroll Saw: Any scroll saw on the market can be used to cut the patterns in this book. Several features on my saw that I find invaluable are a variable speed control and an easy blade release.

Blades: My saw requires straight, pinless blades. I recommend a spiral saw blade because of the numerous direction changes that need to be made as the patterns are cut. My favorite spiral blade has 41 teeth per inch and a .042 kerf.

Electric Drill: An electric drill is needed to make the starter holes. I use a ⁵⁄₃₂-inch drill bit where I can. For smaller openings, I use a ³⁄₃₂-inch drill bit.

Rotary Carving Tool: I use a rotary power carving tool fitted with a tapered grinding stone to remove the burrs and soften the edges of my scrolled fish. A knife or sanding stick will also work well for this task.

Burning Tool: Really stubborn burrs can be removed with a woodburning tool. I also use a woodburner to add fine details, such as fins and eyes, before I sand the scrolled piece.

Electric Sander: For the final overall sanding of the flat surfaces, I use a small electric hand sander. I sand the work first with a medium-grit sandpaper followed by a fine-grit sandpaper. A block of scrap wood fitted with sandpaper is another good option.

Wood: Any type of wood will work well for scrolling the patterns in this book. For smaller projects, I prefer to use ⁵⁄₃₂ inch, three-ply Finnish birch. I stack cut the more popular patterns, but never cut more than three layers of birch at a time. For larger projects, I recommend ¼ inch wood. If your project will be used outside, be sure to choose a plywood that is suitable for outdoor use.

Enlarging the Patterns

For reasons of printing and publishing, the size of this book restricts the size of the patterns I can give you. I know there are several ways to enlarge a pattern; the easiest being the copying machine down at your local office supply store. This method is fine if you want an exact copy of a pattern, but if you are like me, you will want to alter these patterns to fit a specific scrolling project. For this, I use a projector.

I have found a projector to be an easy, accurate way to enlarge a pattern to any size I want. I have even enlarged the sailfish in this book to eight feet long. It now hangs on the once-blank wall of a local restaurant. If you don't own a projector, check with your local library. Many libraries have projectors for public use.

I recently discovered an even easier, more accurate and definitely faster way to get my patterns enlarged. I simply take the pattern to a local blueprint printing company. They can enlarge any printed material to 400%. Look in the phone book under "blueprint" or inquire at a nearby construction company.

The patterns in this book can be scrolled as they are printed here in this book, but I would recommend enlarging them to at least 200% for the best results. The very detailed pieces, like the triple Mahi Mahi or the Grouper, should be enlarged about 300%. Otherwise, the detail will be too small to be

visually effective—and may be too small to even saw out easily.

scraps of paper that remain on the finished piece can be peeled off easily.

A Word About the Patterns

The patterns in this book have been shop-tested for accuracy. The areas to be cut out are filled with black. If you choose to trace the pattern, I suggest that you mark the cut out areas with a dot from a red marker to avoid confusion.

In most cases, each species has two patterns. The larger pattern is the scrolling pattern. All of the lines on this pattern are to be cut. The smaller pattern is a burning guide. I suggest that you use a woodburner to add any detail lines shown in these guides. These burn lines will give some definition to the areas where the fins and the tail meet the body and make your finished project look more realistic.

Because most of my scrolled fish are used as wall hangings, I enlarge the patterns I want to use to about 200% at the local blueprinting company—larger if required for the space I need to fill. I use a stencil spray adhesive to attach the pattern directly to the wood. I drill and saw through the paper pattern. Any

Basic Cutting Instructions

The following instructions can be applied to any of the patterns in this book. Be sure to read through all the instructions before you begin.

1. My first step is to drill starter holes in all of the areas to be cut out. I use a $\frac{5}{32}$ inch drill bit where I can. Some smaller areas call for a smaller hole. I find that my saw blade won't fit through a hole smaller than $\frac{3}{32}$ inch.

2. When all the starter holes are drilled, I cut the outside line of the pattern. It is important to follow the line carefully.

3. When the outline of the fish is completely cut out, I am ready to make the inside cuts. I start with the cutout areas in the extremities first, such as the tail or the fins. This will take the strain off the piece during later cuts. I use a cardboard box to support

Make the outside cut; then the inside cuts. I enlarged this pattern and traced it directly onto the wood using a projector. I marked the areas to cut out with a red dot. The cutouts on the patterns in this book are colored black.

I use a rotary carving tool to remove burrs and round the edges of the piece. This tool is fitted with a tapered grinding stone.

Stubborn burrs can be removed with a woodburning tool. I also use the woodburner to etch in detail lines. These lines are shown on the burning guide that accompanies each pattern.

the project if it hangs over the edge of the saw table.

4. After all the inside cuts are made, I look for zig-zag cuts or cuts that went off the line. I use my power carving tool fitted with a sanding drum bit to correct any problems.

5. Next, I remove all the burrs from the piece. I don't feel a sculpture looks finished if the edges are sharp, so I use the power carver, fitted with a tapered grinding stone, to gently round over the edges. I do all of the edges, front and back. Any remaining burrs can be removed with a woodburner.

6. Following the small burning guide, I add the finishing touches to my fish with a woodburner.

7. My last step is to sand both sides of the project. Finnish birch requires only a light sanding with fine 200-grit sandpaper. Hardwood plywood requires a first sanding with 150-grit paper followed by 200-grit. I don't take off too much of the surface; just enough to make sure all the pencil marks are gone and the surface is smooth enough to paint.

Painting and Finishing

This is a wide open category. Use your imagination and the materials with which you are comfortable. Some tips and techniques that I recommend follow.

Stain: You may choose to stain the finished project. In my experience, I have found that most birches do not have enough grain to make this a good choice, though it may work well for other hardwoods.

Varnish: I put a urethane finish on everything I do—with the exception of pieces that are painted with metallic paints finished with acid patinas, because the finish turns the acid-treated areas too dark. I choose a satin finish; a gloss finish gives too much reflection.

Paint: Paint is a good choice for decorative pieces. I have painted many finished projects that were designed to hang on an outside wall. Be sure to choose paint that will withstand the weather and colors that match the surroundings.

Brass or Copper Paint: This is my most popular finish. I use brass and copper paints that incorporate real brass or copper, which is important when I plan to use acid patinas to really dress a piece up.

Sponge Painting: Most of the pieces in the gallery section of this book are painted with the "damp sponge method." The materials I use include acrylic or metallic paints and a sea sponge. The sea sponge is important because of its open texture. A standard sponge's texture is too fine to give the random dots of paint that are needed for a good sponge finish. On occasion, I also use pouncer sponges, round sponges mounted on a stick.

1. Choose a base color and apply it to the whole project, including all the edges. I allow this color to dry before moving on to the next step, though that isn't always necessary. (Hint: I have found the metallic paints seem to work well for base coats. They shine through and give more depth to the colors.)

2. Dip a damp sponge into the next paint color and dab off any excess paint onto an old piece of newspaper. Apply the paint by dabbing the sponge only in the areas where you wish the paint to appear.

3. Rinse out the sponge and repeat Step 2 with the next color.

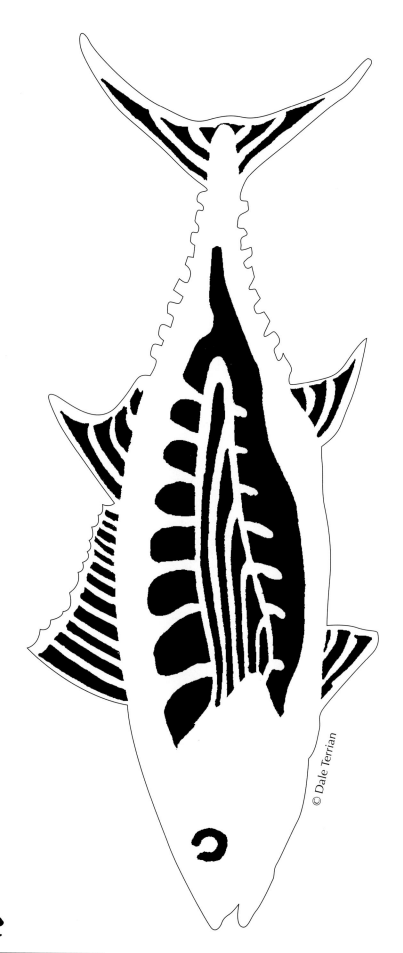

Burning Guide
Burn the lines that
separate the fins
and the body. Burn
the detail lines
around the mouth
and gills.

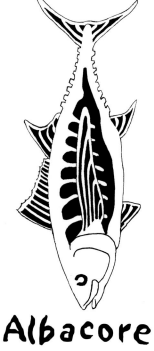

Albacore

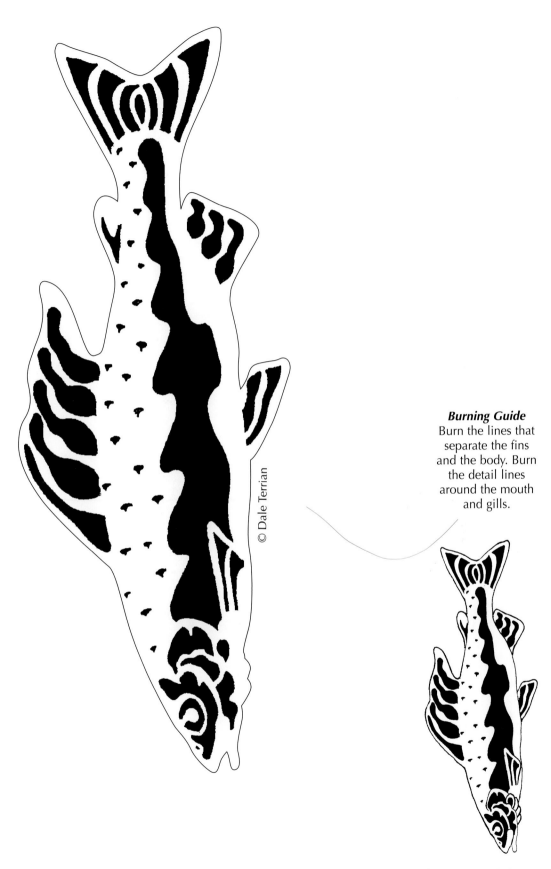

Burning Guide
Burn the lines that separate the fins and the body. Burn the detail lines around the mouth and gills.

© Dale Terrian

Arctic Grayling

Marine Life Patterns for the Scroll Saw

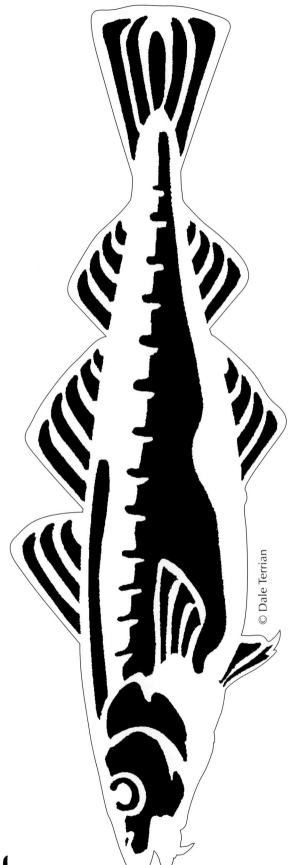

Burning Guide
Burn the lines that separate the fins and the body. Burn the detail lines around the mouth and gills.

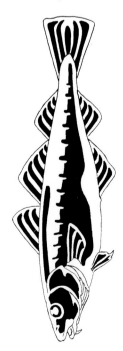

© Dale Terrian

Atlantic Cod

Marine Life Patterns for the Scroll Saw

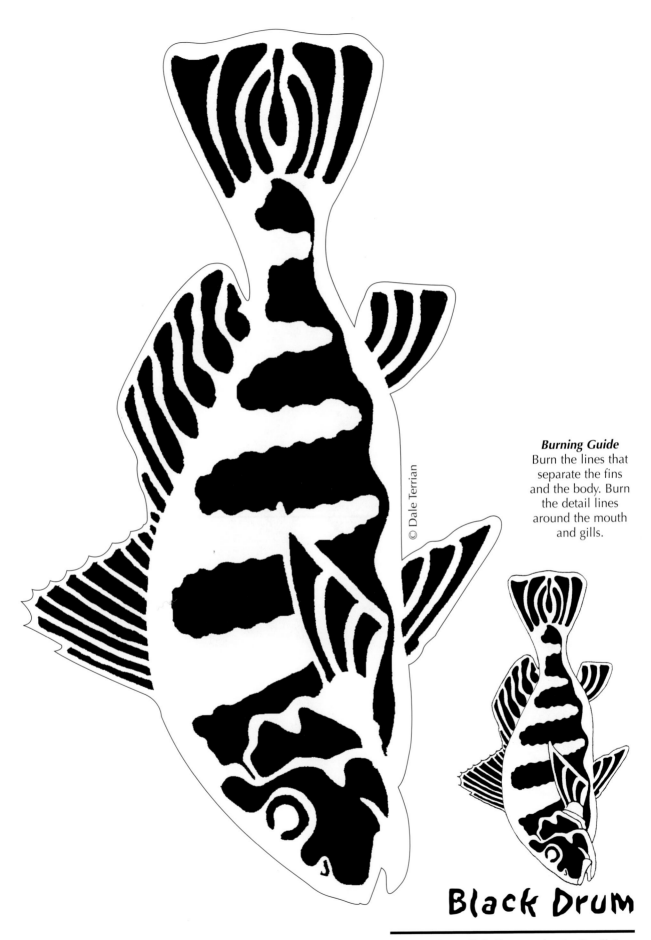

Burning Guide
Burn the lines that separate the fins and the body. Burn the detail lines around the mouth and gills.

© Dale Terrian

Black Drum

Marine Life Patterns for the Scroll Saw

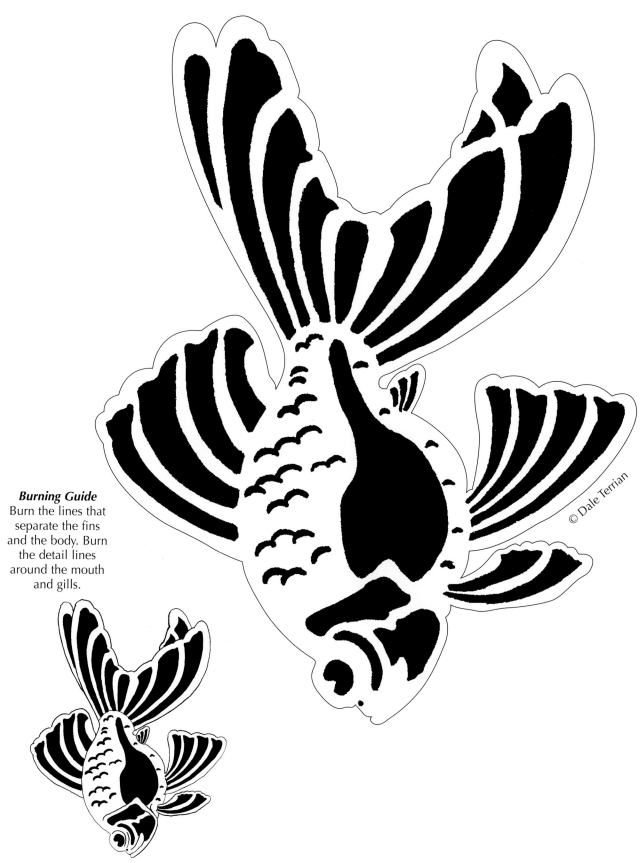

Burning Guide
Burn the lines that separate the fins and the body. Burn the detail lines around the mouth and gills.

© Dale Terrian

Black Moor

Marine Life Patterns for the Scroll Saw

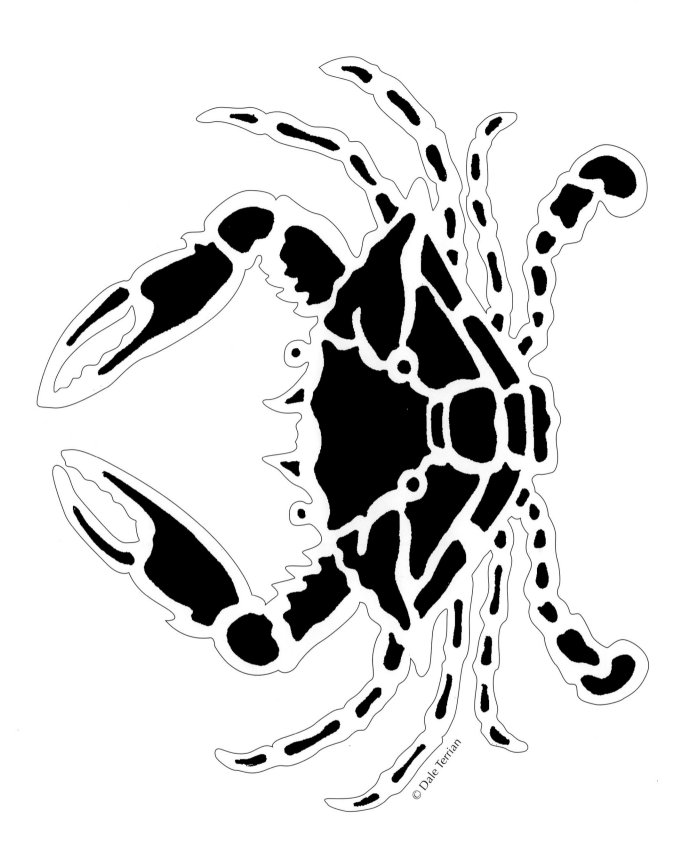

© Dale Terrian

Blue Crab

Marine Life Patterns for the Scroll Saw

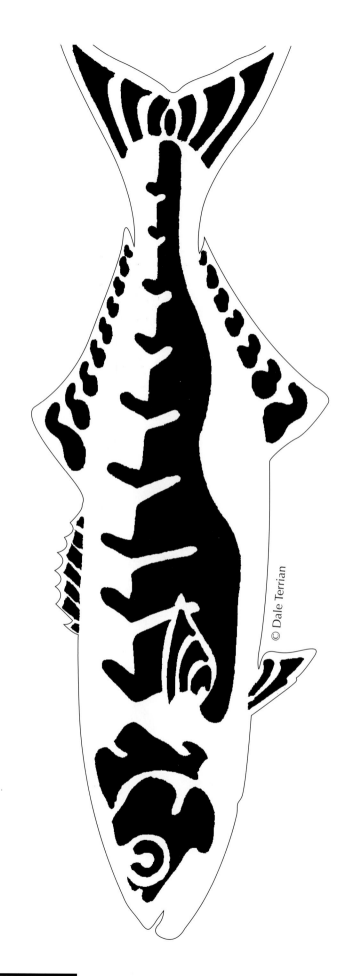

Burning Guide
Burn the lines that separate the fins and the body. Burn the detail lines around the mouth and gills.

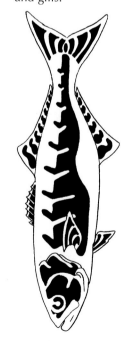

© Dale Terrian

Blue Fish

Marine Life Patterns for the Scroll Saw

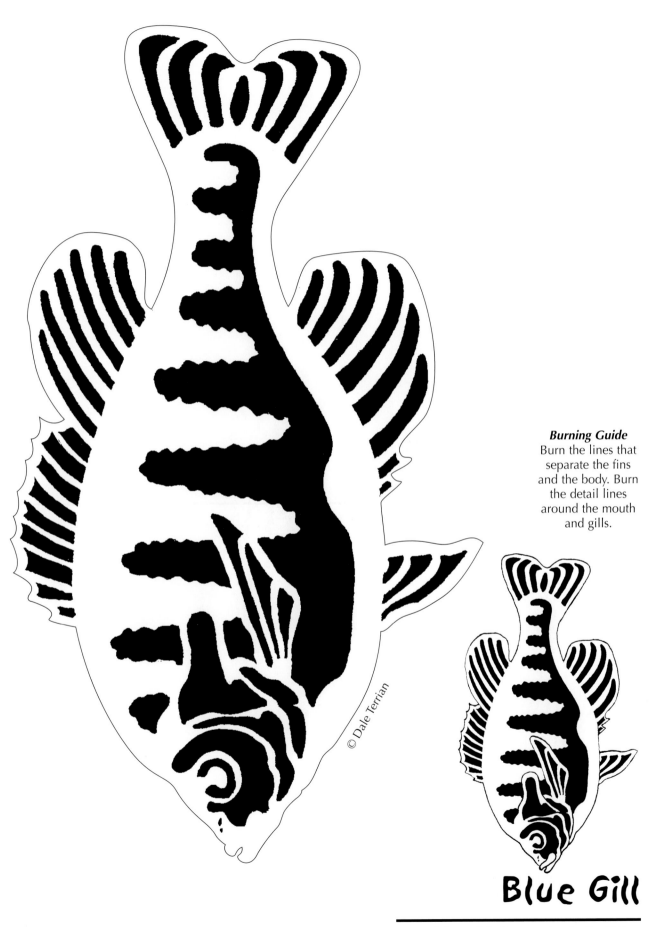

Burning Guide
Burn the lines that
separate the fins
and the body. Burn
the detail lines
around the mouth
and gills.

© Dale Terrian

Blue Gill

Marine Life Patterns for the Scroll Saw

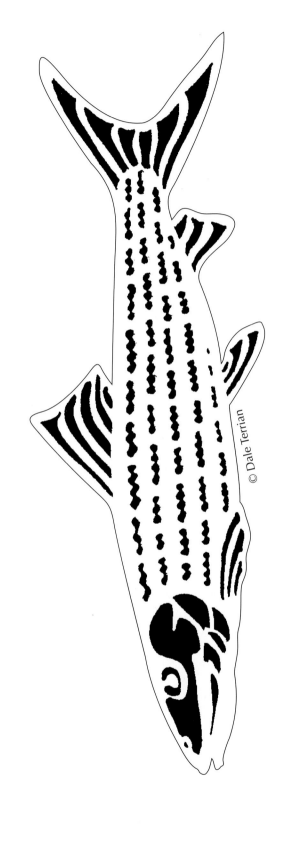

Burning Guide
Burn the lines that
separate the fins
and the body. Burn
the detail lines
around the mouth
and gills.

© Dale Terrian

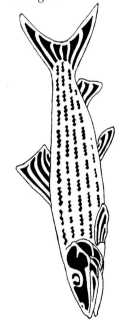

Bone Fish

Marine Life Patterns for the Scroll Saw

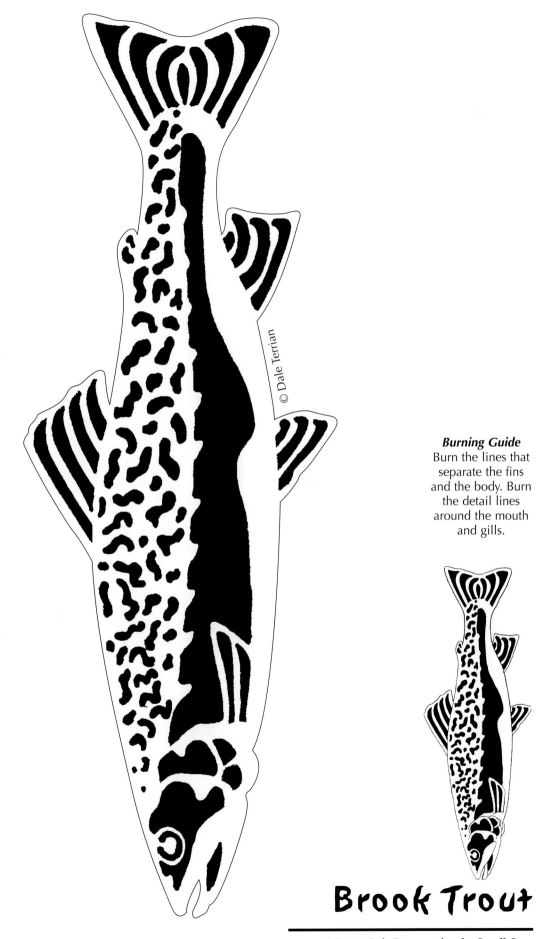

© Dale Terrian

Burning Guide
Burn the lines that
separate the fins
and the body. Burn
the detail lines
around the mouth
and gills.

Brook Trout

Marine Life Patterns for the Scroll Saw

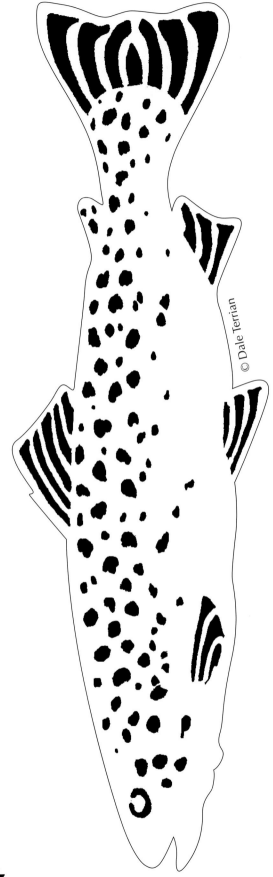

Burning Guide
Burn the lines that
separate the fins
and the body. Burn
the detail lines
around the mouth
and gills.

© Dale Terrian

Brown Trout

Marine Life Patterns for the Scroll Saw

14

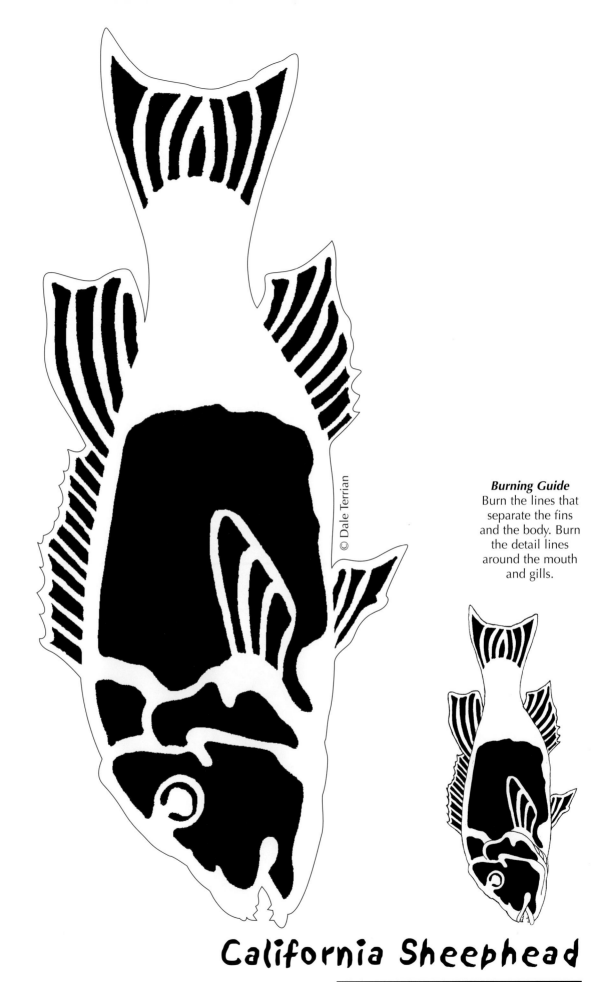

© Dale Terrian

Burning Guide
Burn the lines that
separate the fins
and the body. Burn
the detail lines
around the mouth
and gills.

California Sheephead

Marine Life Patterns for the Scroll Saw

15

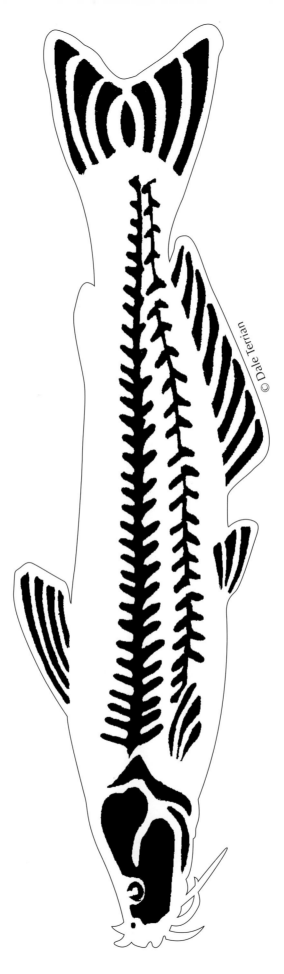

©Dale Terrian

Burning Guide
Burn the lines that separate the fins and the body. Burn the detail lines around the mouth and gills.

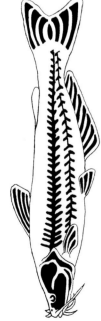

Catfish

Marine Life Patterns for the Scroll Saw

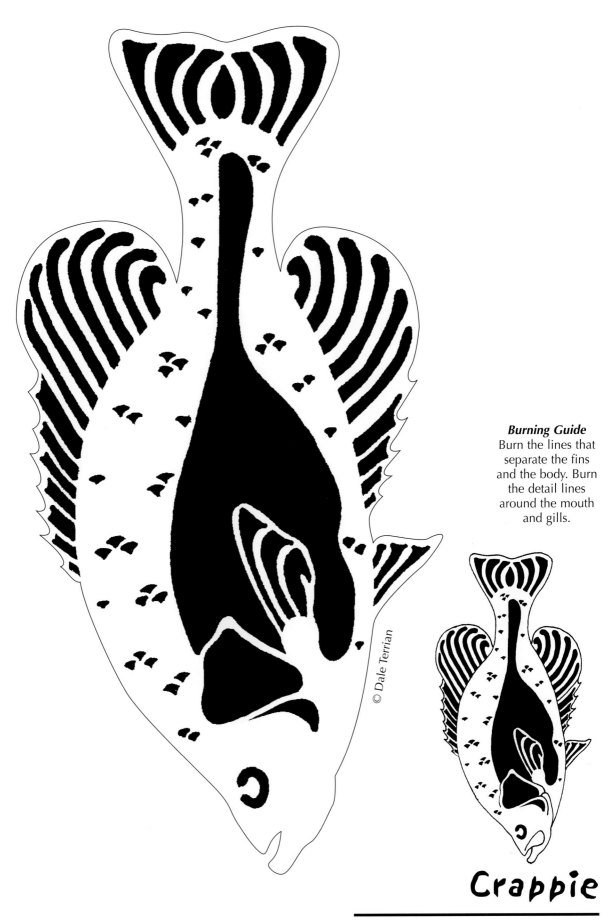

Burning Guide
Burn the lines that separate the fins and the body. Burn the detail lines around the mouth and gills.

© Dale Terrian

Crappie

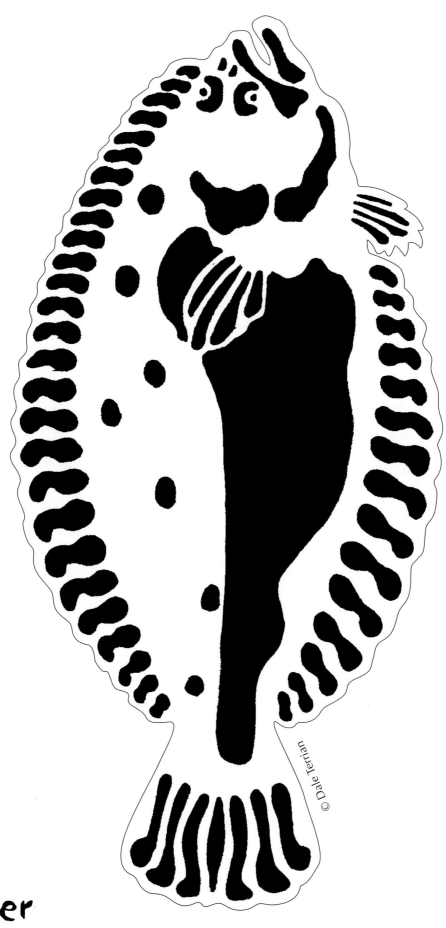

Flounder

Marine Life Patterns for the Scroll Saw

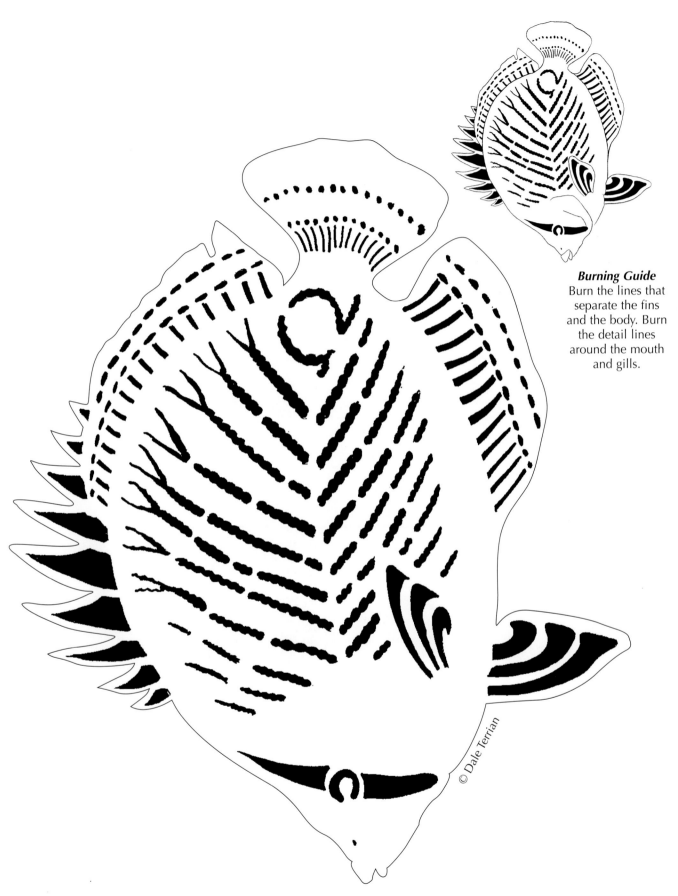

Burning Guide
Burn the lines that separate the fins and the body. Burn the detail lines around the mouth and gills.

© Dale Terrian

Four Eye Butterfly Fish

Marine Life Patterns for the Scroll Saw

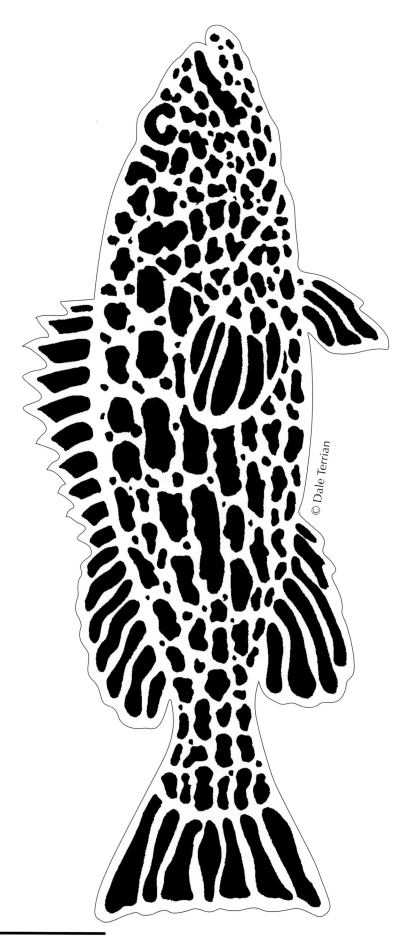

Grouper

Marine Life Patterns for the Scroll Saw

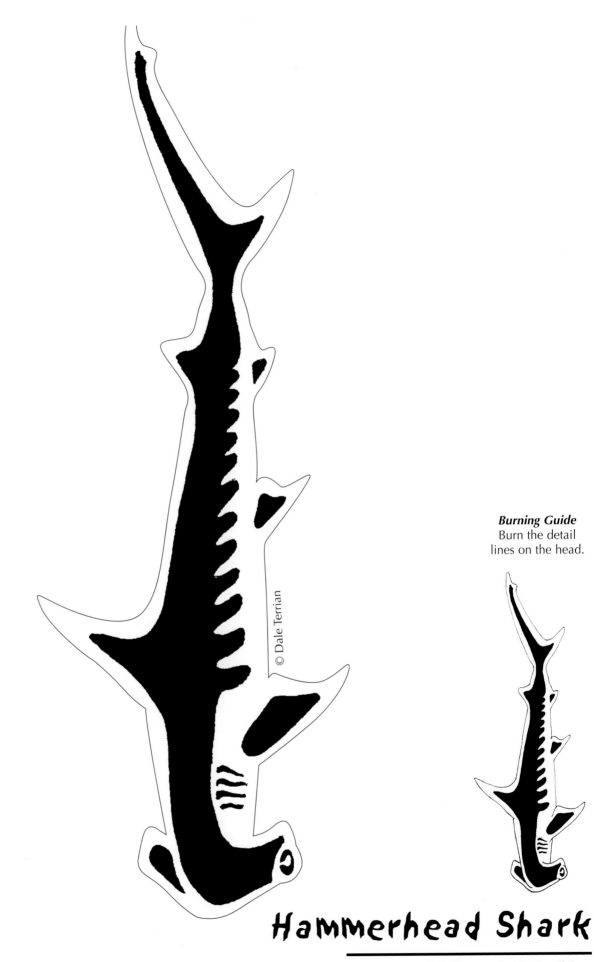

© Dale Terrian

Burning Guide
Burn the detail
lines on the head.

Hammerhead Shark

Marine Life Patterns for the Scroll Saw

21

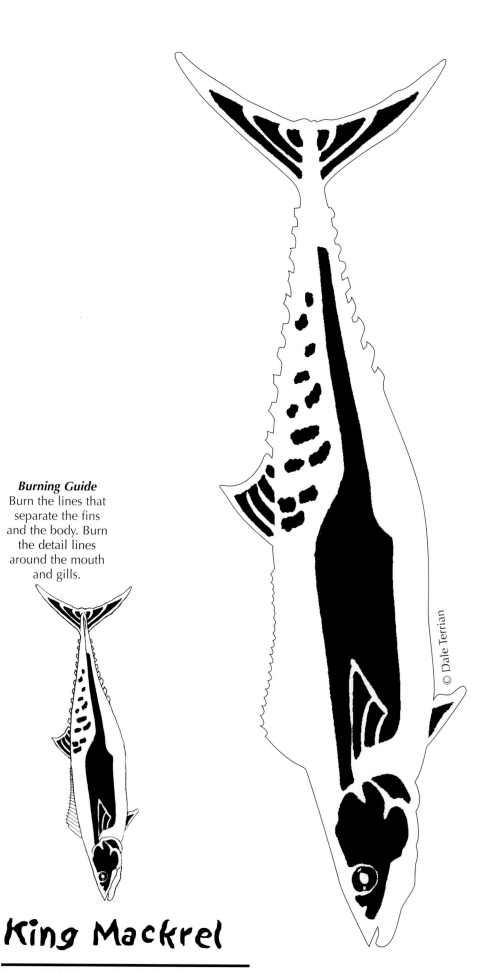

Burning Guide
Burn the lines that separate the fins and the body. Burn the detail lines around the mouth and gills.

King Mackrel

Marine Life Patterns for the Scroll Saw

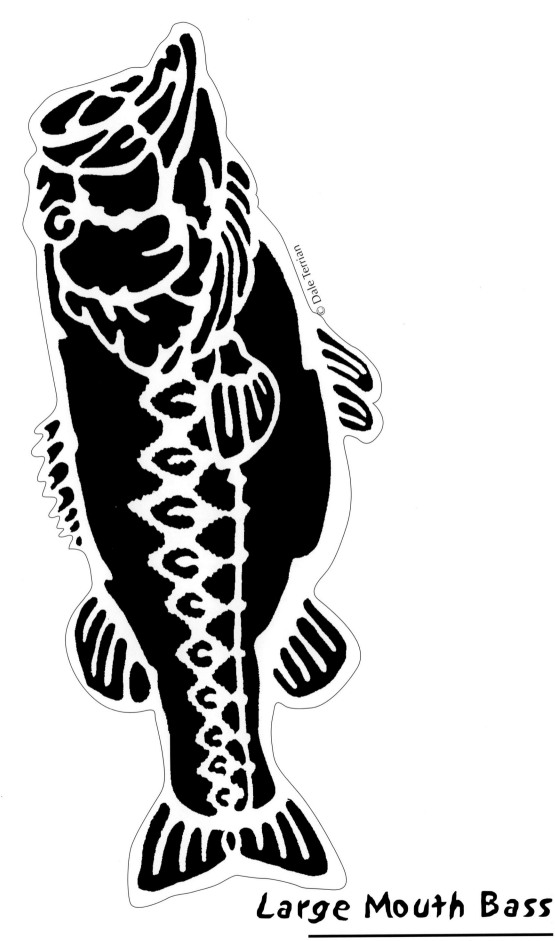

© Dale Terrian

Large Mouth Bass

Marine Life Patterns for the Scroll Saw

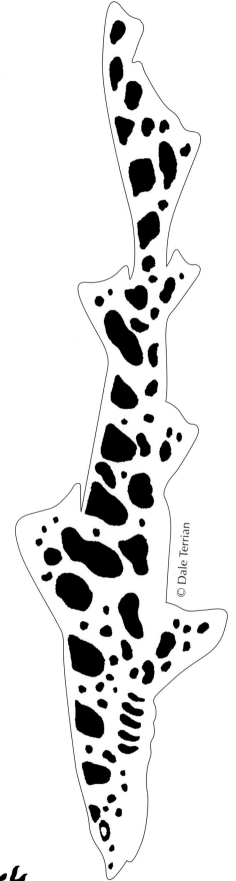

Burning Guide
Burn the detail
lines for the
mouth.

Leopard Shark

Marine Life Patterns for the Scroll Saw

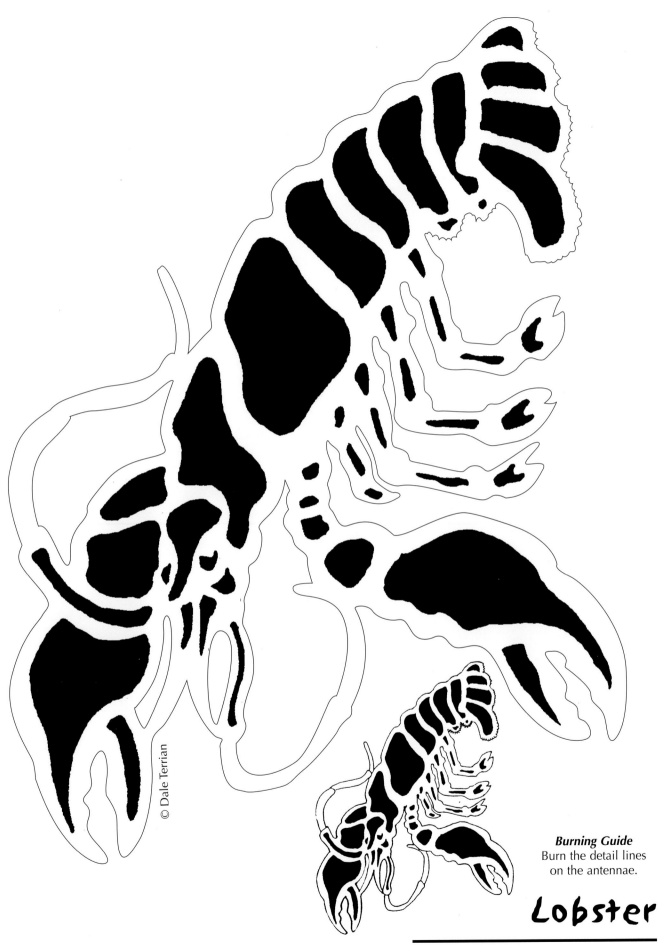

© Dale Terrian

Burning Guide
Burn the detail lines
on the antennae.

Lobster

Marine Life Patterns for the Scroll Saw

25

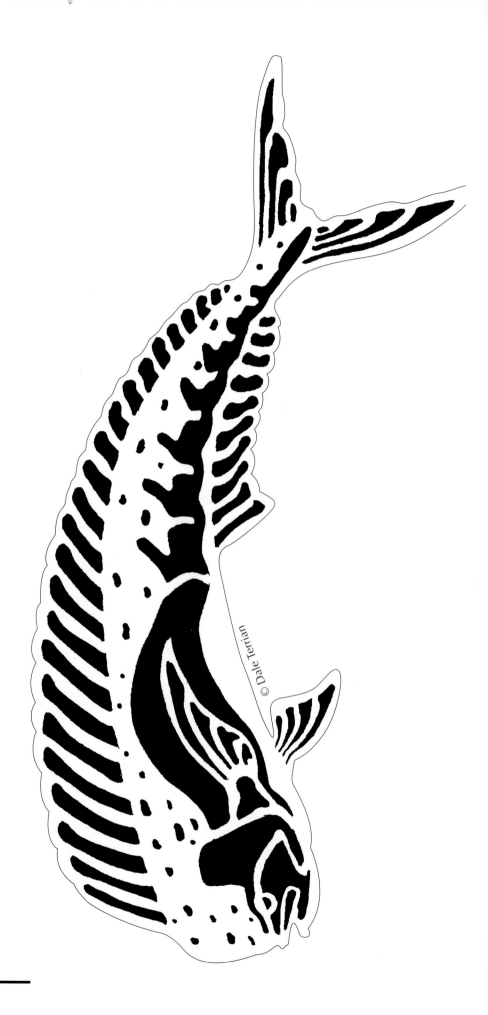

Mahi Mahi

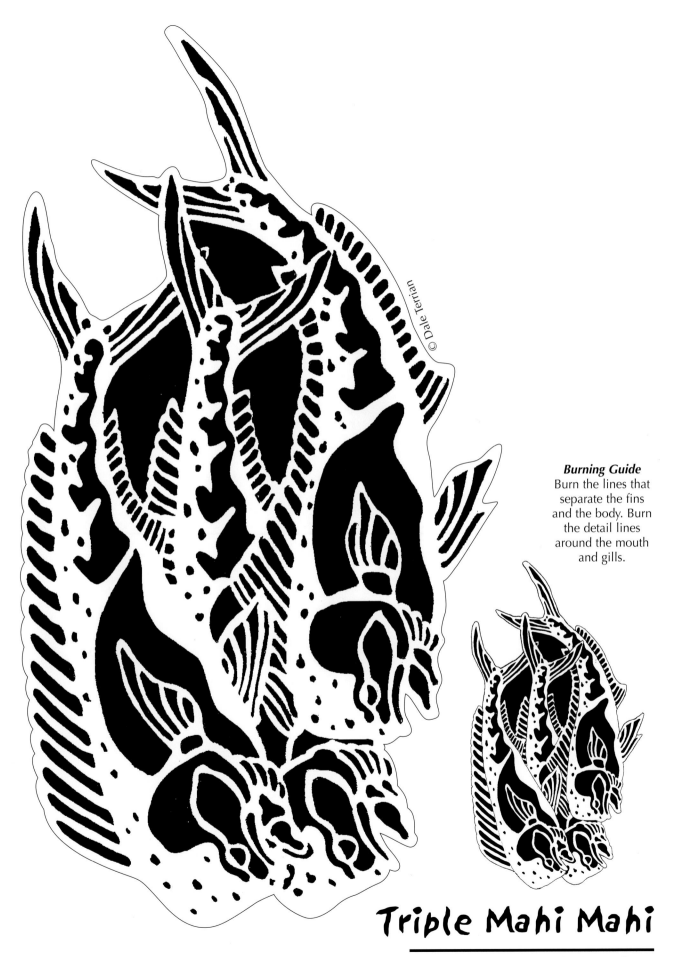

© Dale Terrian

Burning Guide
Burn the lines that separate the fins and the body. Burn the detail lines around the mouth and gills.

Triple Mahi Mahi

Marine Life Patterns for the Scroll Saw

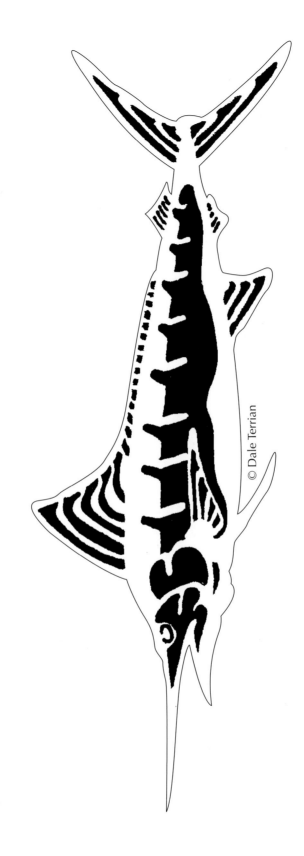

© Dale Terrian

Burning Guide
Burn the lines that
separate the fins
and the body. Burn
the detail lines
around the mouth
and gills.

Marlin

Marine Life Patterns for the Scroll Saw

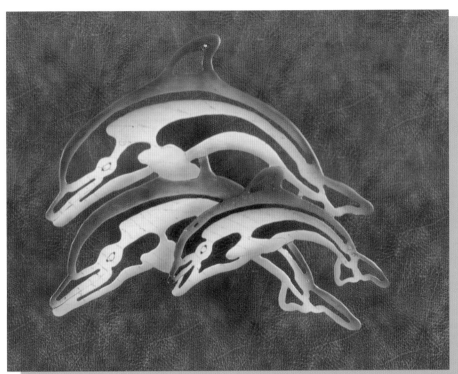

Triple Porpoise,
pattern on page 43.

This is a popular piece. I have cut this one out in many sizes—most in the four-foot range. Four feet is the jigsaw size, but this grouping also looks great in whatever size will fit whatever wood I have on hand.

I have painted this pattern in so many different ways and in so many different colors that I don't know which I would recommend. I can tell you one of my strangest requests, though. This couple had a large carved sailboat painted red and blue hanging on the living room wall. It is lovely, but it didn't fill enough of the wall to suit them. So when they saw my two-foot triple porpoise, they thought it would fit perfectly into the scene. The size was ideal, but the colors of the one I had on display didn't suit. I told them I had another one and would attempt to stain it to match the sailboat. I wasn't confident about the outcome, but the piece turned out beautifully. What I learned from that challenge was that my scrolled pieces can be finished almost any way I wish and still be great.

If you're still looking for a painting suggestion, try choosing three colors that work well together, such as silver, white and blue. Use the silver for the base color. Sponge the white on the bottom of each fish. Sponge the blue on the top of each fish. Leave the middle silver. And if you don't like the results, choose a different set of three colors and repaint. It's that easy.

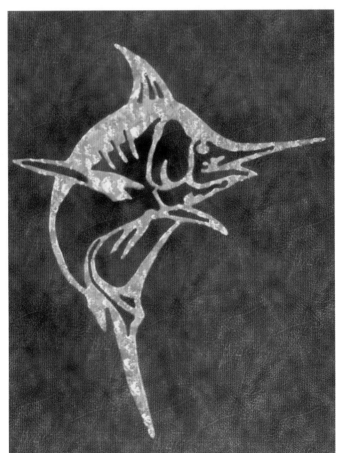

Marlin, *pattern on page 28.*

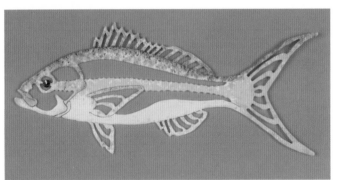

Yellow Tail, *pattern on page 67.*

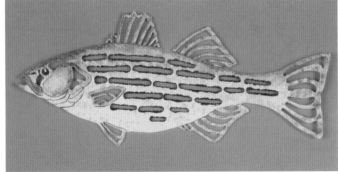

Striped Bass, *pattern on page 59.*

Gallery

Marine Life Patterns for the <u>Scroll Saw</u>

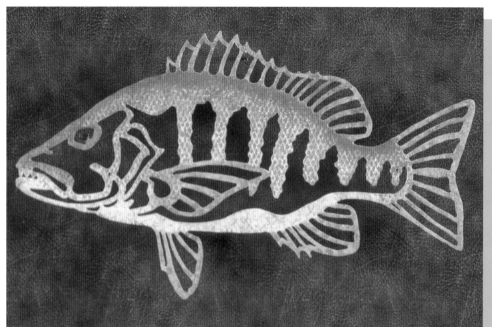

**Red Snapper,
*pattern on page 47.***

The snapper requires a different painting procedure. First, I used white as my base color. Then I airbrushed (you may choose to sponge paint) a pink color, very sparsely, near the bottom of the fish. As I moved up the fish, I sprayed a heavier coat of the same color. On the top inch or so of the fish, I lightly sponged on some soft yellow with the pink.

Now comes the fun part. I bought some artist's screening that looked to be about the right size for fish scales. I temporarily fastened my fish to a scrap board and thumb tacked the screen over the fish. I stretched the screen so that the openings formed diamond shapes instead of squares and made sure the sharp points of the diamonds pointed to the top and bottom of the fish. Then I airbrushed a crimson red paint through the screen, lightly near the bottom and heavier toward the top. Then I removed the screen and sponged some red on the fins. (I did not airbrush the fins through the screen. Remember, fins don't have scales.)

This technique can be used on any fish that has a prominent scale pattern. Give this technique a try on the red snapper or the tarpon (page 61). It's fun and effective.

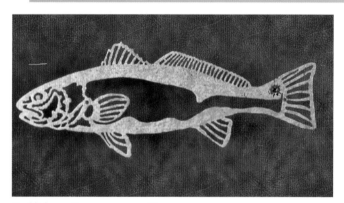

Redfish, *pattern on page 45.*

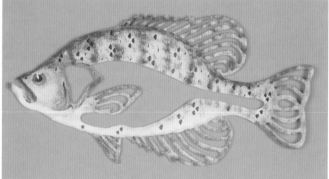

Crappie, *pattern on page 17.*

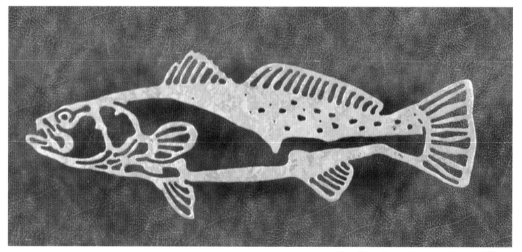

Gallery

Marine Life Patterns for the Scroll Saw

Sea Trout, *pattern on page 52.*

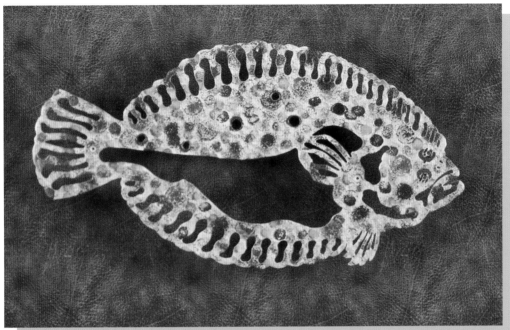

Flounder,
pattern on page 18.

I used just four colors of acrylic paint on this fish. They are sandalwood, burnt sienna, raw umber and bronze gold. First, I painted the whole fish on both sides with sandalwood, making sure to cover all the edges. When the paint was dry, I dabbed a piece of damp sea sponge into the bronze gold paint and blotted most of it off on a piece of newspaper.

Then, I dabbed the sponge all over the fish, leaving most of the sandalwood color to show through.

Next, I used two round sponges sticks, called "pouncers." One is 1/2 inch in diameter; the other is 3/4 inch. I dipped these sponges into the burnt sienna and dabbed the excess off on the piece of paper; then I pressed these sponges all over the fish. I repeated the process with the raw umber, adding enough spots to give the mottled look of a flounder.

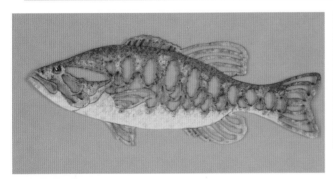

Small Mouth Bass, *pattern on page 55.*

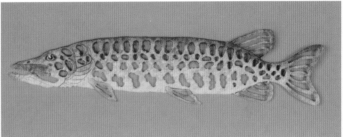

Northern Pike, *pattern on page 37.*

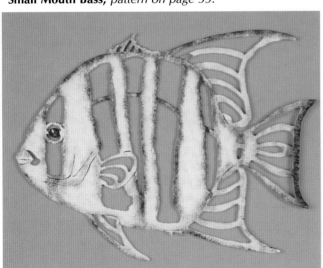

Spade Fish, *pattern on page 57.*

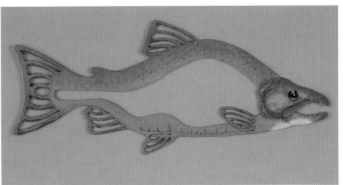

Sockeye Salmon, *pattern on page 56.*

Gallery

Marine Life Patterns for the Scroll Saw

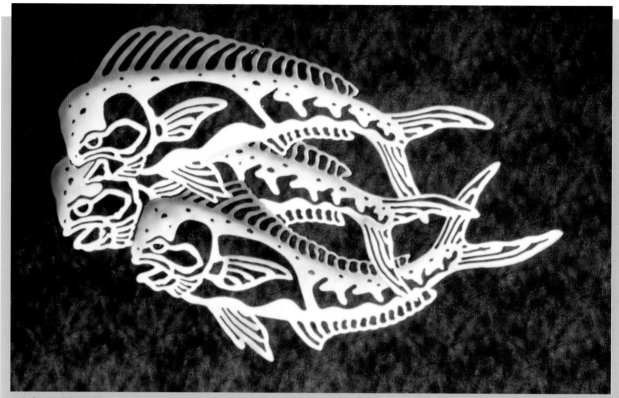

Triple Mahi Mahi, *pattern on page 27.*

Cutting this threesome of fish is a challenge, but the basic rules stay the same: Cut out the areas in the extremities first. I sawed all of the small details completely before I removed any of the larger interior areas. This gave me the rigidity I wanted throughout the sawing process. Beyond that, this pattern is just a bit more time-consuming than the rest, but very worth the extra effort.

The painting process is a little more involved, too. I airbrushed this one, which called for a lot of masking and re-masking; but I think you could get a fine looking group of fish by sponge painting this piece. You'll need bright yellow, transparent green, Phalo blue and deep blue acrylic paints. Use the bright yellow as the base paint to cover all of the sides and the edges. Then, lightly sponge the transparent green on the top third of each fish. Allow the green to go farther down on the heads. I apply it heavy enough to completely cover the yellow as I reach the top of each fish. Next, sponge the Phalo blue on the very top inch or so of each fish. Apply this color to the entire back fin as well. Finally, add some deep blue at the very top of each fish and in a random pattern all over the back fin.

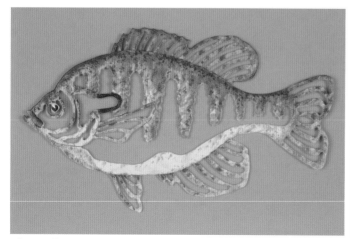

Blue Gill, *pattern on page 11.*

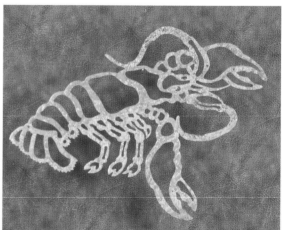

Lobster *pattern on page 25.*

Gallery

Marine Life Patterns for the Scroll Saw

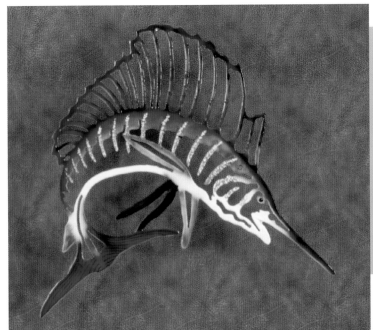

Sail Fish,
pattern on page 48.

I painted this fish using my airbrush system. I don't expect everyone has one of these setting around, so I'll tell you the colors I used and suggest that you try sponge painting with standard acrylic paints.

For this piece, I used white silver pearl, sailfish blue, deep blue, black, teal blue and gold. First, I painted the whole fish, both sides, with white silver pearl. Next, I painted the top half of the fish with sailfish blue. Then, I painted the sail and the very top part of the fish, the tail and the fins with deep blue. On each rib, I put a few spots of very light teal blue and a few spots of gold. I put a few spots of gold on the gill covers, too. I finished by adding a touch of black on the two bottom front fins.

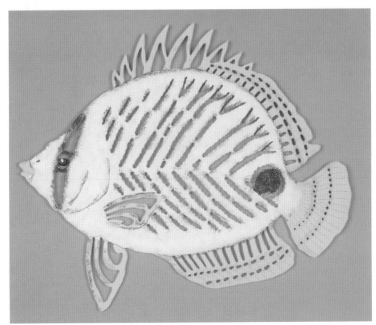

Four Eye Butterfly Fish, *pattern on page 19.*

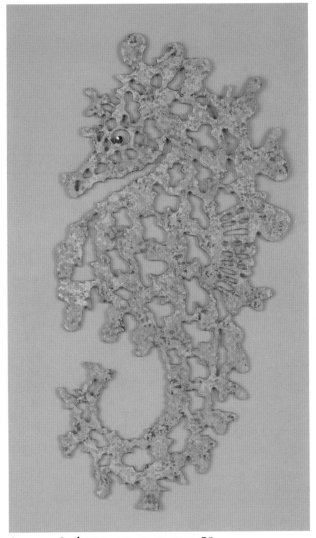

Sargasso Seahorse, *pattern on page 50.*

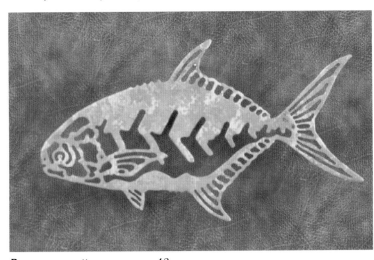

Pompano, *pattern on page 42.*

Gallery

Marine Life Patterns for the Scroll Saw

Grouper,
pattern on page 20.

Here's another challenge. The grouper doesn't require special sawing techniques; it's just that there's a lot to saw out. I invested a lot of time on this fish, but the results are very dramatic. Be sure to take your time and saw the extremities first.

I painted this fish to look like the yellow fin grouper. I think this species is the most colorful of the groupers. I used gold for the base color. Then, I sponged on enough Cadmium red to cover almost half of the gold coloring. Next, I sponged on a little ocher—just enough for the highlights—and then a little black. Finally, I sponged a bit of yellow on the front fin—just enough to give this fish its name.

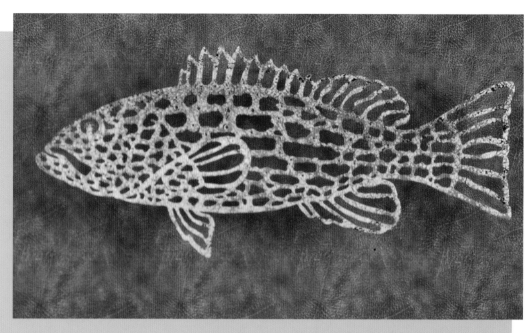

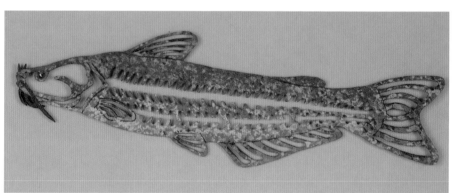

Catfish, *pattern on page 16.*

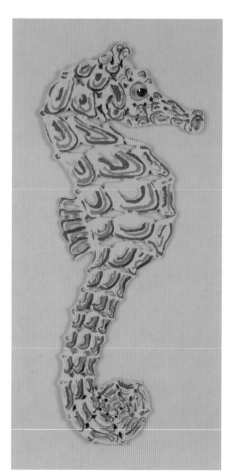

Seahorse, *pattern on page 51.*

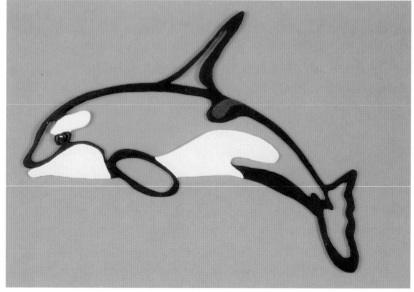

Orca Whale, *pattern on page 38.*

Gallery

Marine Life Patterns for the Scroll Saw

Shrimp,
pattern on page 54.

Finding a shrimp pink color can be tough, so I'll tell you how I make my own. I just mix about five parts pink with one part orange. This mix makes a fairly passable shrimp pink.

When you have the shrimp pink made, paint both sides and all edges of the piece with this color. Then, using the damp sponge method, apply the pink, covering about a quarter of the entire piece. Now apply the crimson, mainly to the front edges of each body segment, the legs and the claws.

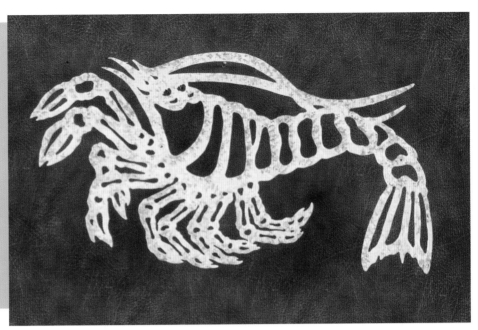

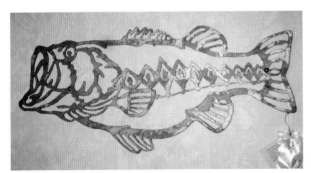

Large Mouth Bass, *pattern on page 23.*

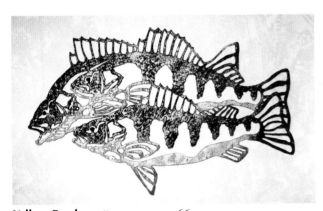

Yellow Perch, *pattern on page 66.*

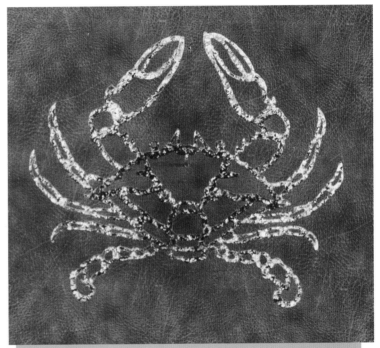

Blue Crab,
pattern on page 9.

Use five colors to paint this crab: silver, teal blue, Phalo blue, deep blue and crimson red. First, cover the whole piece with silver on both sides and on all the edges. Using the damp sponge method, dab on the teal blue. Next, sponge on the Phalo blue and then the deep blue in equal amounts. Be sure to leave plenty of the silver paint showing through. Finally, dab some crimson red on the front half of the large claws.

Gallery

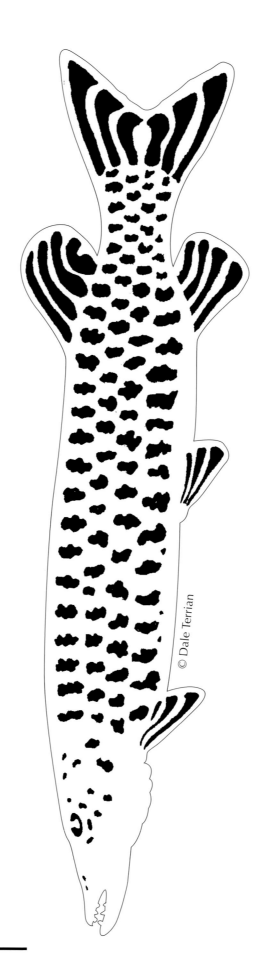

Burning Guide
Burn the lines that separate the fins and the body. Burn the detail lines around the mouth and gills.

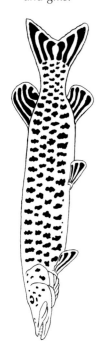

© Dale Terrian

Musky

Marine Life Patterns for the Scroll Saw

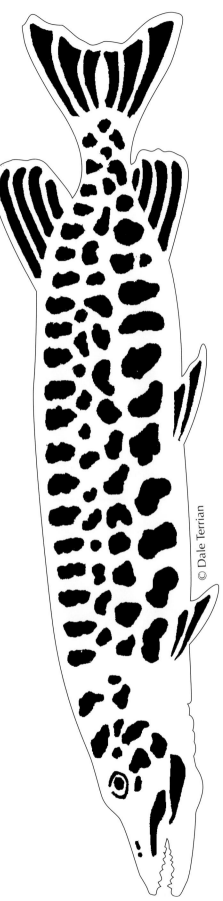

© Dale Terrian

Burning Guide
Burn the lines that
separate the fins
and the body. Burn
the detail lines
around the mouth
and gills.

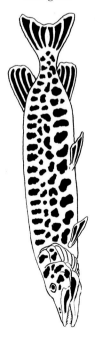

Northern Pike

Marine Life Patterns for the Scroll Saw

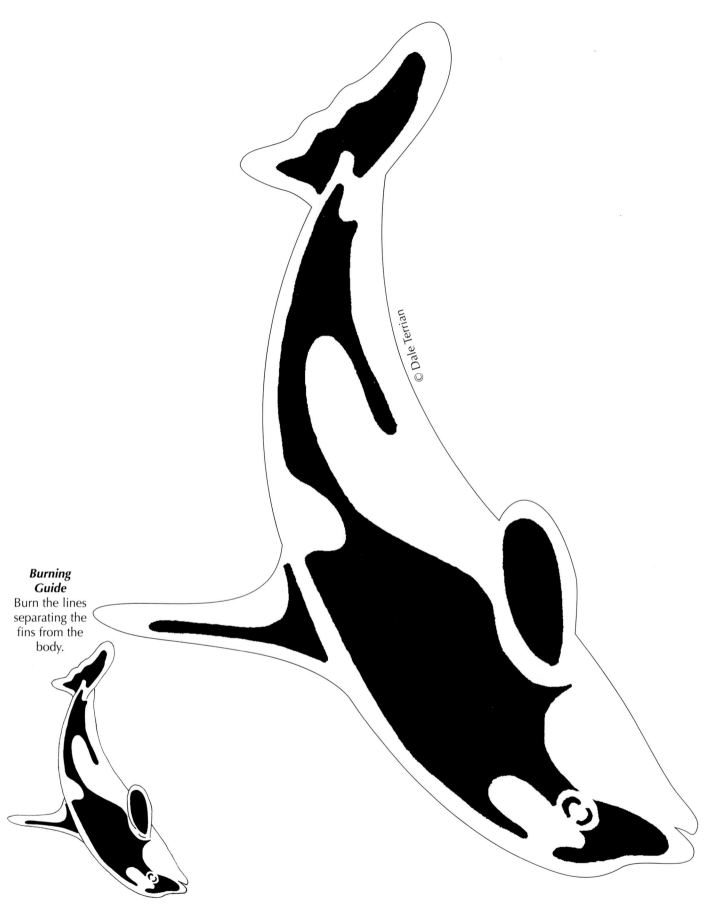

© Dale Terrian

Burning Guide
Burn the lines separating the fins from the body.

Orca Whale

Marine Life Patterns for the Scroll Saw

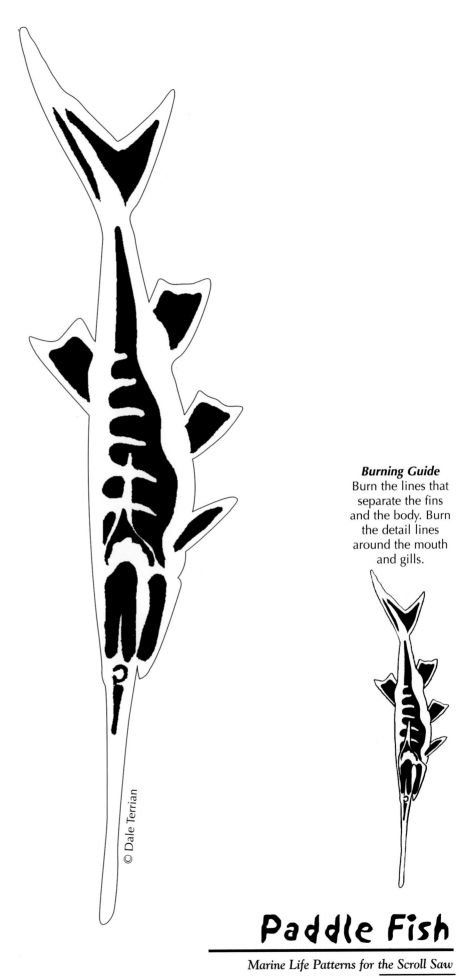

© Dale Terrian

Burning Guide
Burn the lines that separate the fins and the body. Burn the detail lines around the mouth and gills.

Paddle Fish

Marine Life Patterns for the Scroll Saw

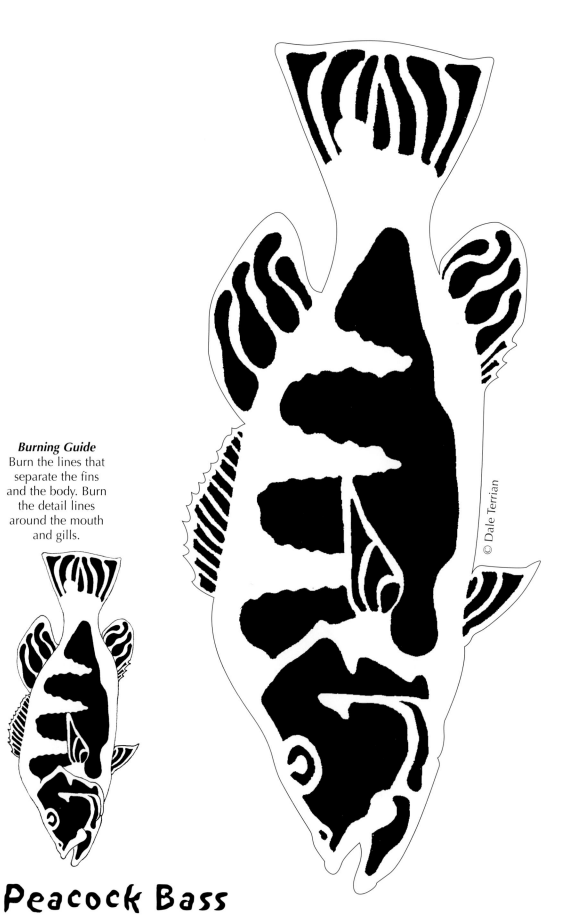

Burning Guide
Burn the lines that
separate the fins
and the body. Burn
the detail lines
around the mouth
and gills.

© Dale Terrian

Peacock Bass

Marine Life Patterns for the Scroll Saw

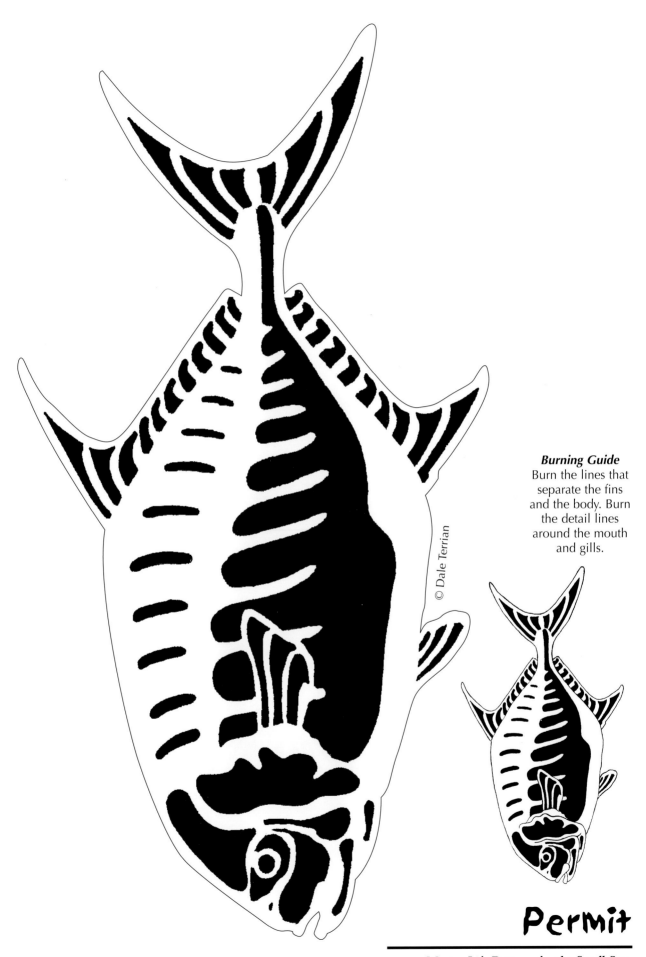

Burning Guide
Burn the lines that separate the fins and the body. Burn the detail lines around the mouth and gills.

© Dale Terrian

Permit

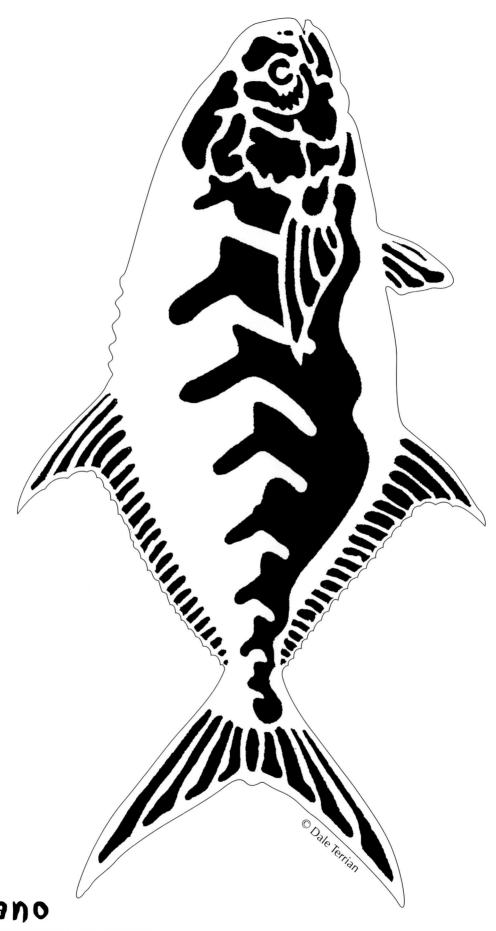

Pompano

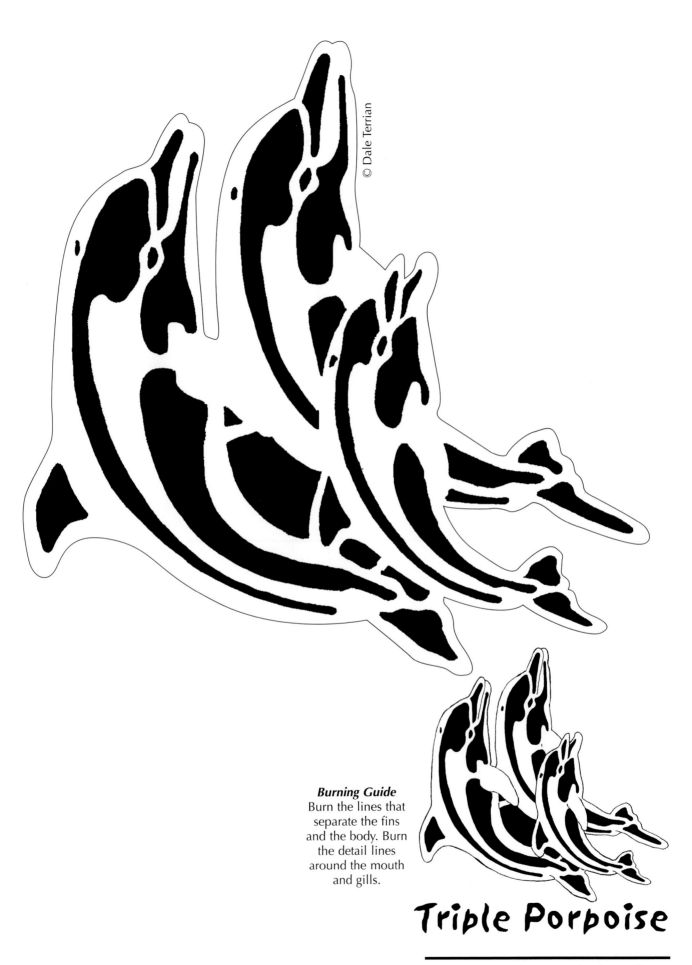

© Dale Terrian

Burning Guide
Burn the lines that separate the fins and the body. Burn the detail lines around the mouth and gills.

Triple Porpoise

Marine Life Patterns for the Scroll Saw

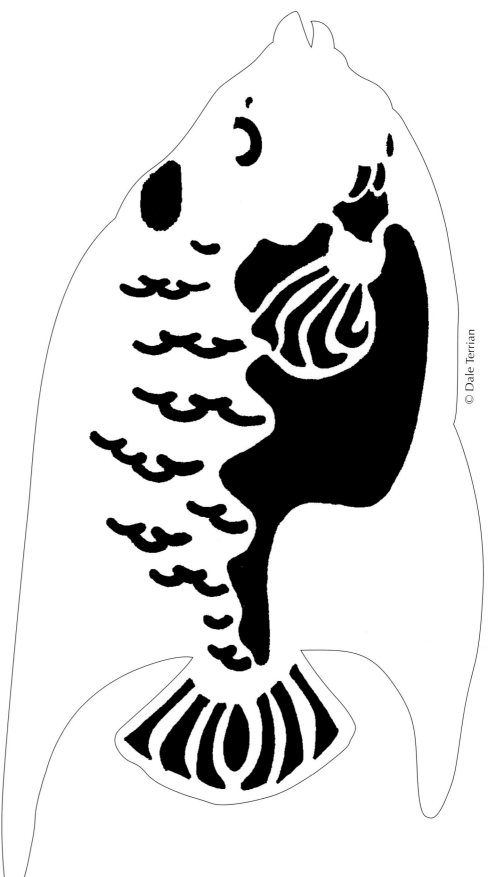

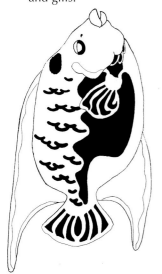

Burning Guide
Burn the lines that
separate the fins
and the body. Burn
the detail lines
around the mouth
and gills.

© Dale Terrian

Queen Angel Fish

Marine Life Patterns for the Scroll Saw

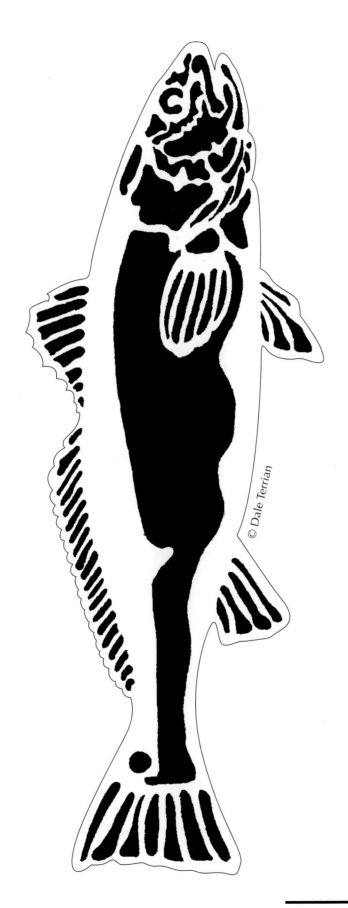

© Dale Terrian

Redfish

Marine Life Patterns for the Scroll Saw

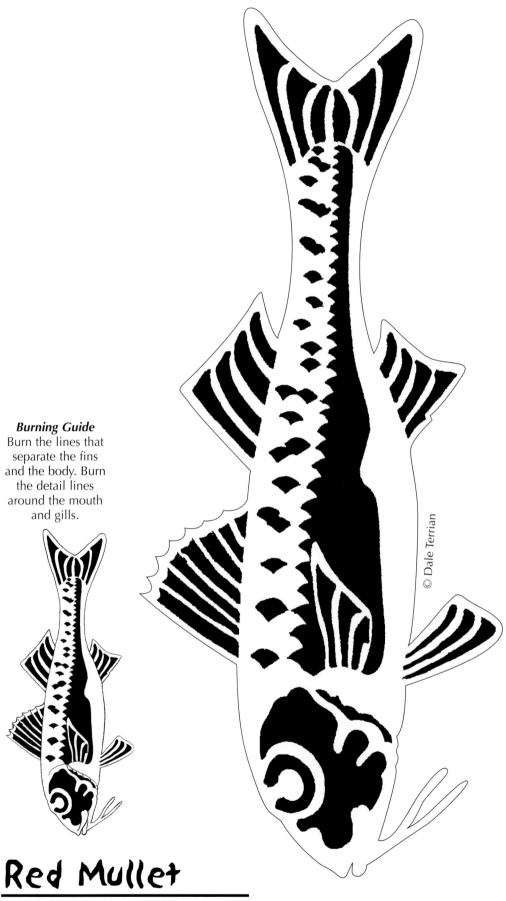

Burning Guide
Burn the lines that separate the fins and the body. Burn the detail lines around the mouth and gills.

© Dale Terrian

Red Mullet

Marine Life Patterns for the Scroll Saw

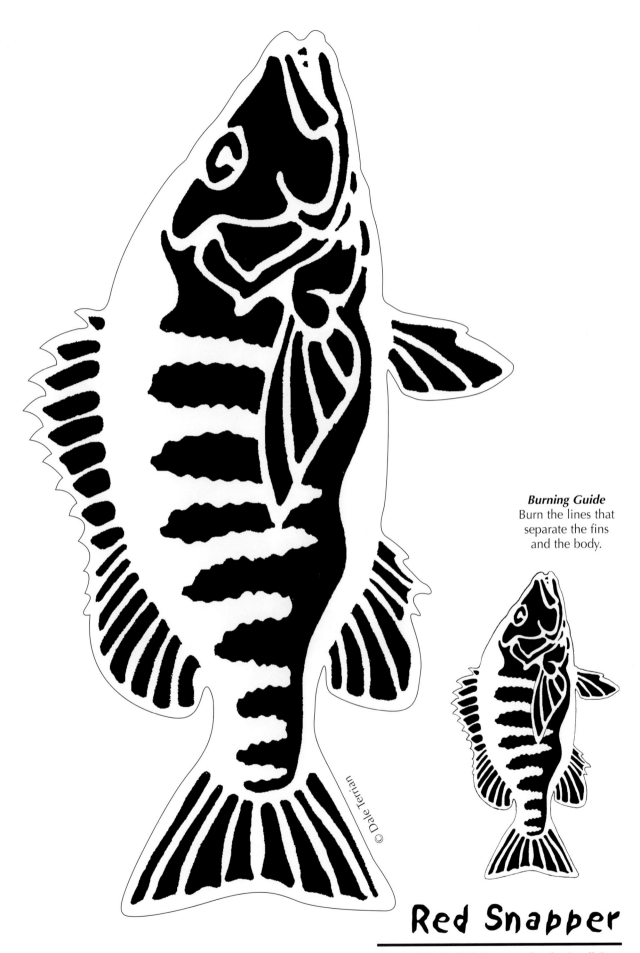

Burning Guide
Burn the lines that separate the fins and the body.

© Dale Terrian

Red Snapper

Marine Life Patterns for the Scroll Saw

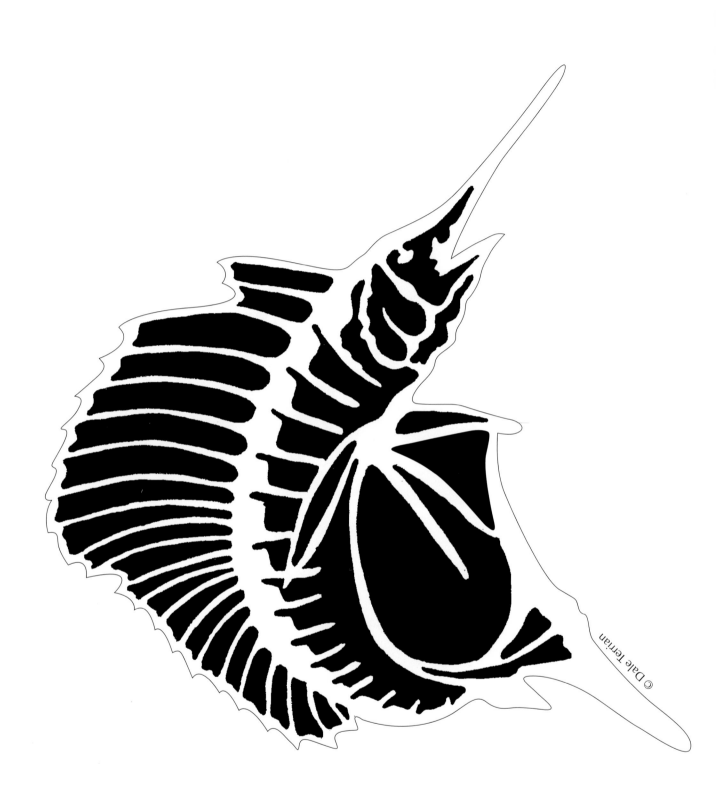

Sail Fish

Marine Life Patterns for the Scroll Saw

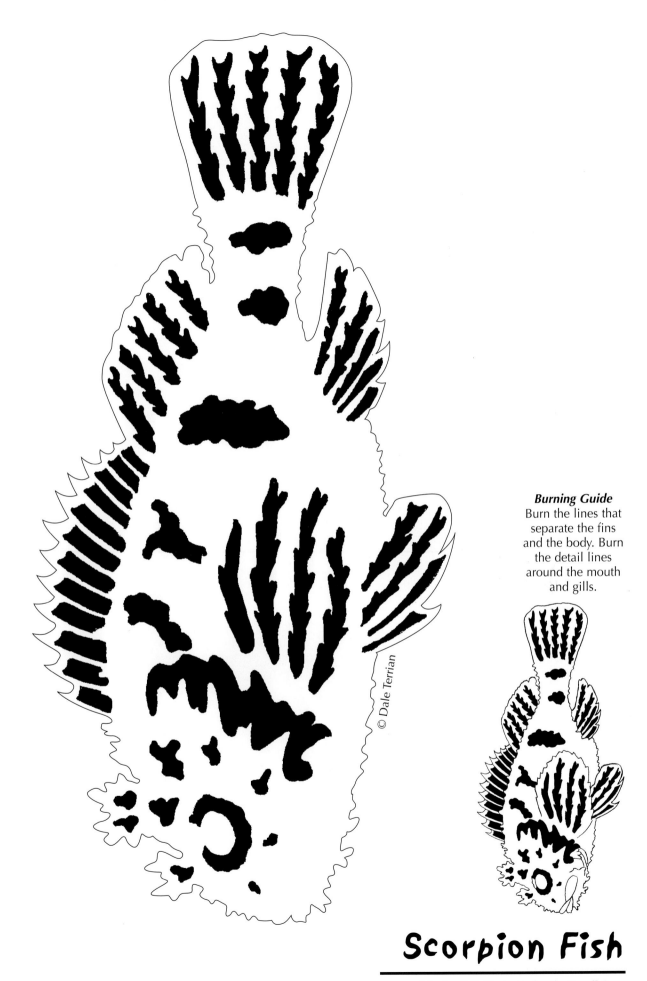

Burning Guide
Burn the lines that separate the fins and the body. Burn the detail lines around the mouth and gills.

© Dale Terrian

Scorpion Fish

Marine Life Patterns for the Scroll Saw

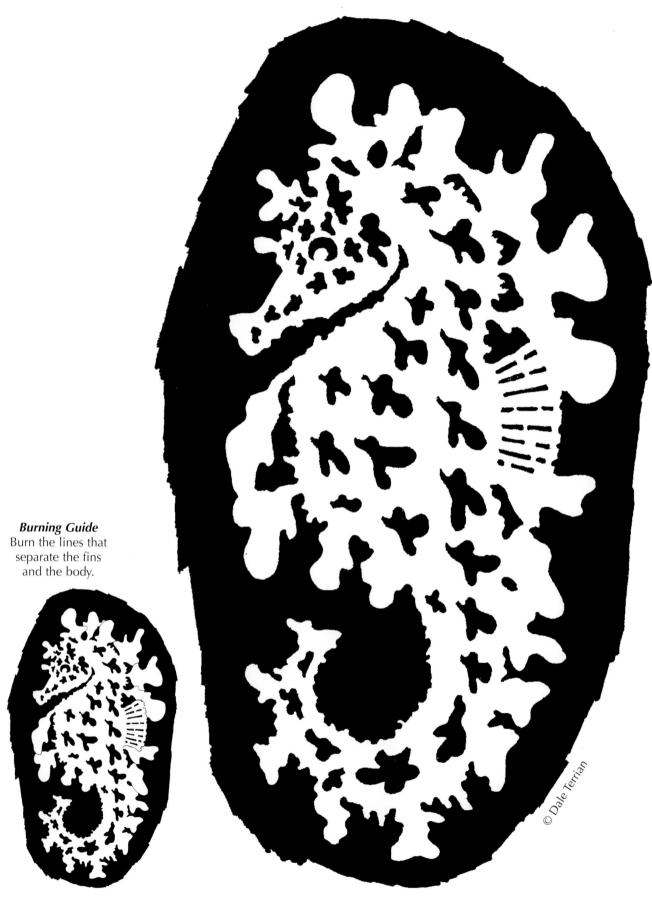

Burning Guide
Burn the lines that
separate the fins
and the body.

© Dale Terrian

Sargasso Seahorse

Marine Life Patterns for the Scroll Saw

50

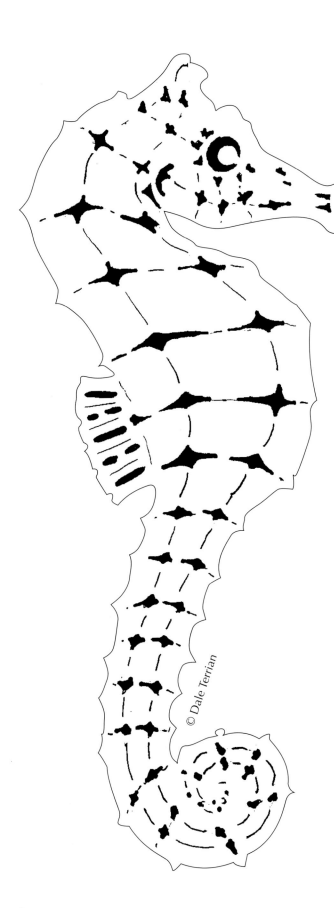

Burning Guide
Burn the detail
lines on the body
and the fin.

© Dale Terrian

Seahorse

Marine Life Patterns for the Scroll Saw

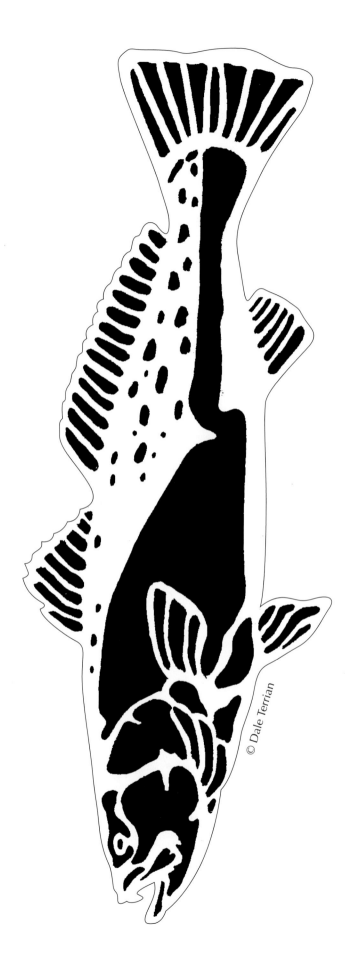

Sea Trout

Marine Life Patterns for the Scroll Saw

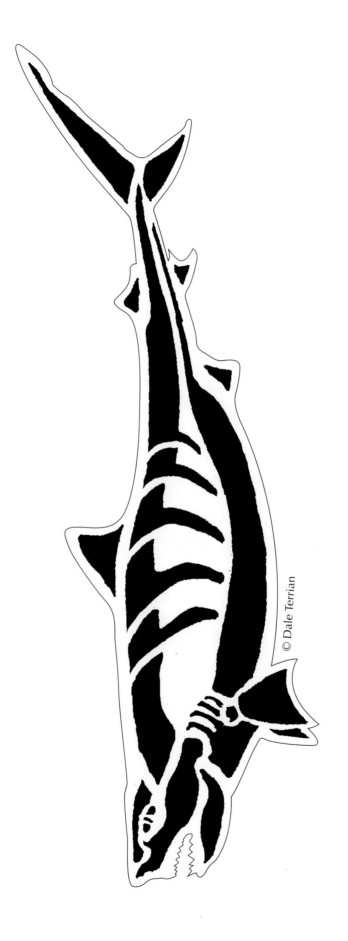

© Dale Terrian

Burning Guide
Burn the lines that
separate the teeth
and the mouth.

Shark

Marine Life Patterns for the Scroll Saw

53

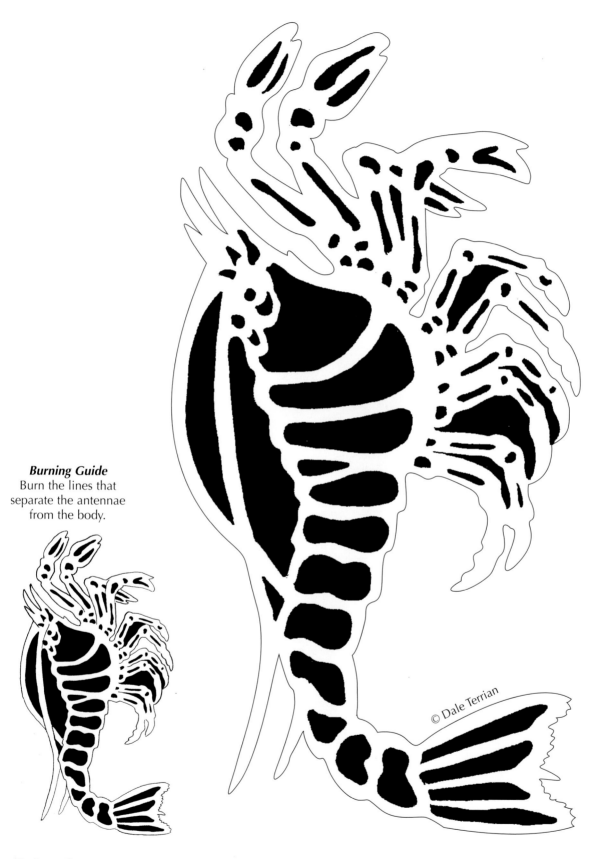

Burning Guide
Burn the lines that separate the antennae from the body.

© Dale Terrian

Shrimp

Marine Life Patterns for the Scroll Saw

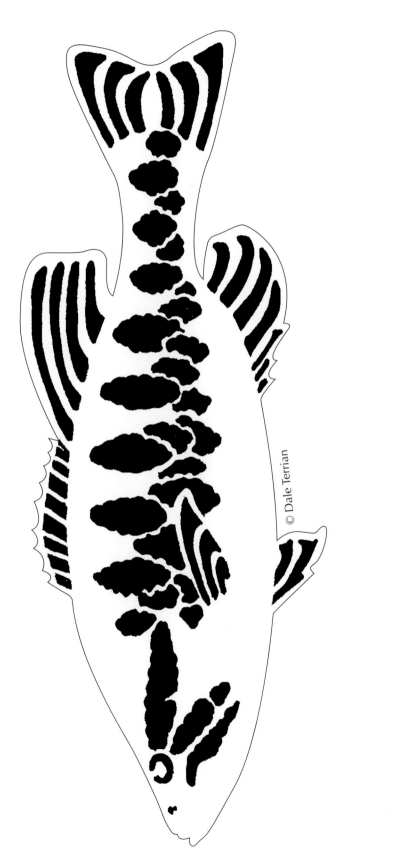

© Dale Terrian

Burning Guide
Burn the lines that
separate the fins
and the body. Burn
the detail lines
around the mouth
and gills.

Small Mouth Bass

Marine Life Patterns for the Scroll Saw

55

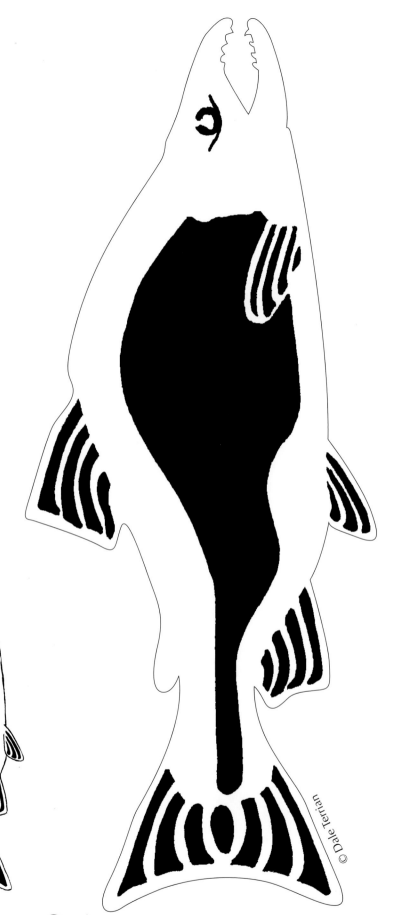

Burning Guide
Burn the lines that separate the fins and the body. Burn the detail lines around the mouth and gills.

© Dale Terrian

Sockeye Salmon

Marine Life Patterns for the Scroll Saw

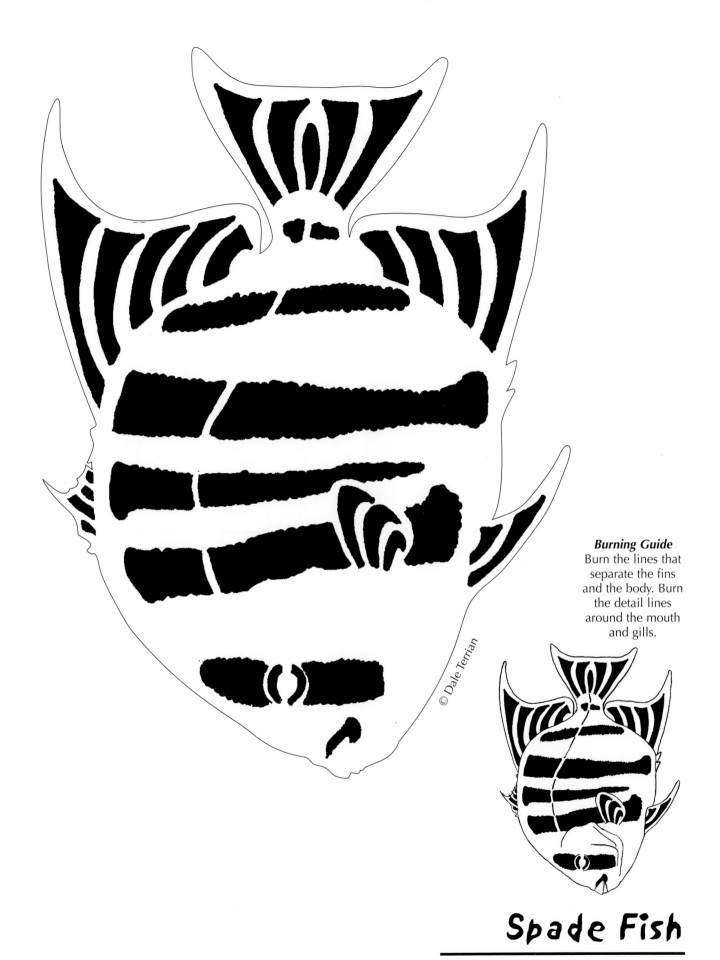

Burning Guide
Burn the lines that separate the fins and the body. Burn the detail lines around the mouth and gills.

©Dale Terrian

Spade Fish

Marine Life Patterns for the Scroll Saw

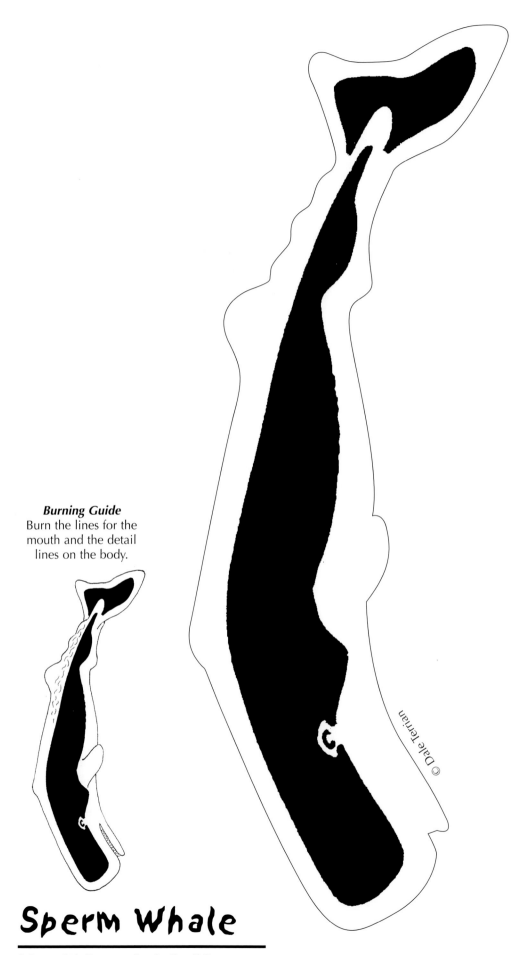

Burning Guide
Burn the lines for the mouth and the detail lines on the body.

© Dale Terrian

Sperm Whale

Marine Life Patterns for the Scroll Saw

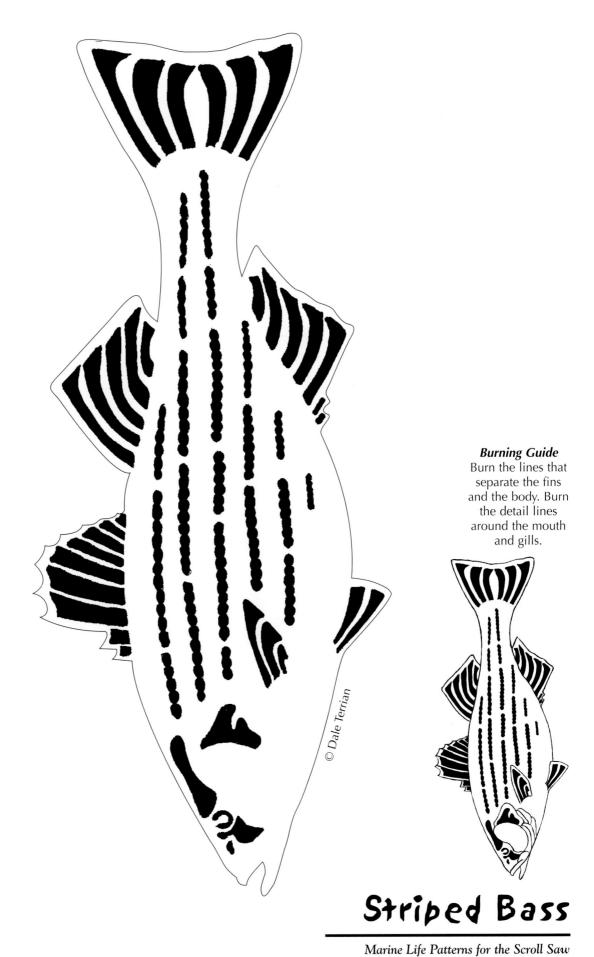

Burning Guide
Burn the lines that separate the fins and the body. Burn the detail lines around the mouth and gills.

© Dale Terrian

Striped Bass

Marine Life Patterns for the Scroll Saw

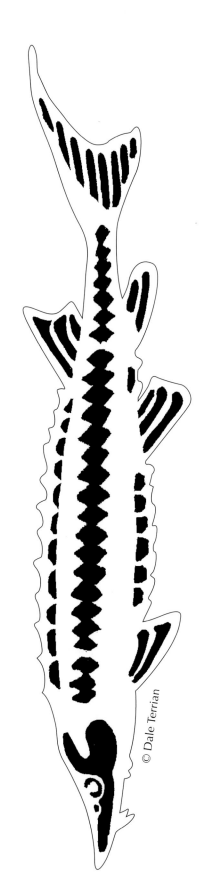

© Dale Terrian

Burning Guide
Burn the lines that separate the fins and the body. Burn the detail lines around the mouth and gills.

Sturgon

Marine Life Patterns for the Scroll Saw

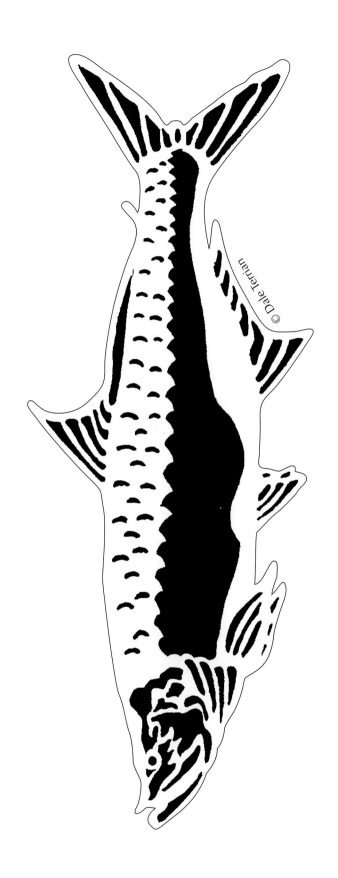

Tarpon

Marine Life Patterns for the Scroll Saw

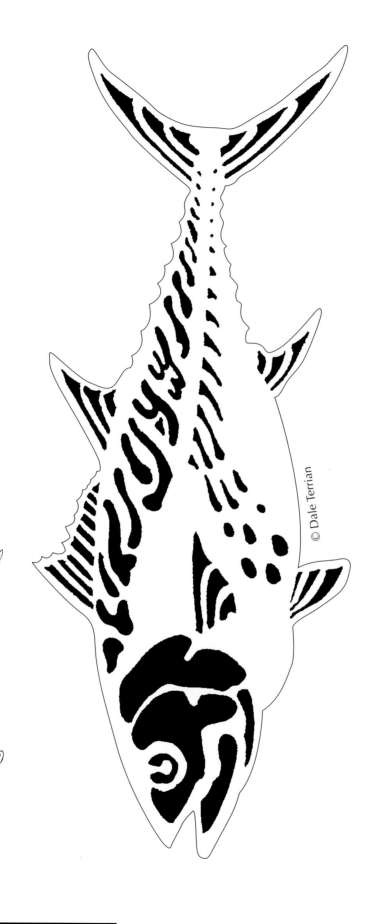

Burning Guide
Burn the lines that
separate the fins
and the body. Burn
the detail lines
around the mouth
and gills.

© Dale Terrian

Tuna

Marine Life Patterns for the Scroll Saw

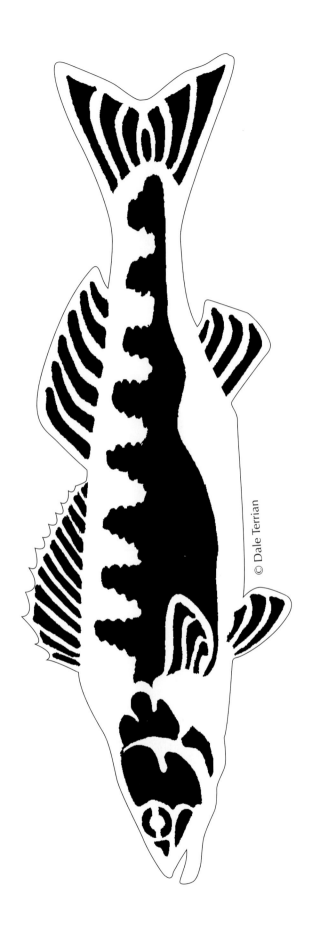

© Dale Terrian

Burning Guide
Burn the lines that separate the fins and the body. Burn the detail lines around the mouth and gills.

Walleye

Marine Life Patterns for the Scroll Saw

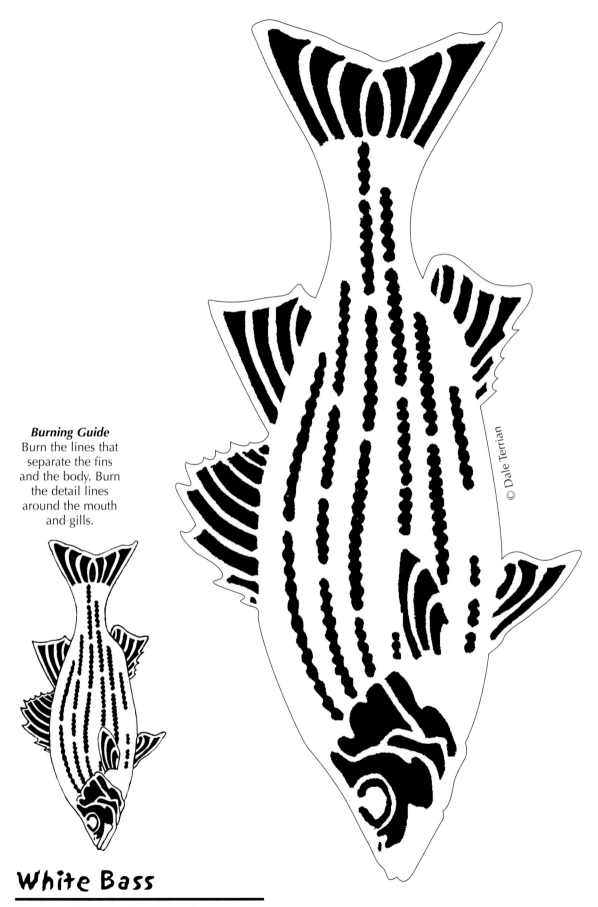

Burning Guide
Burn the lines that separate the fins and the body. Burn the detail lines around the mouth and gills.

© Dale Terrian

White Bass

Marine Life Patterns for the Scroll Saw

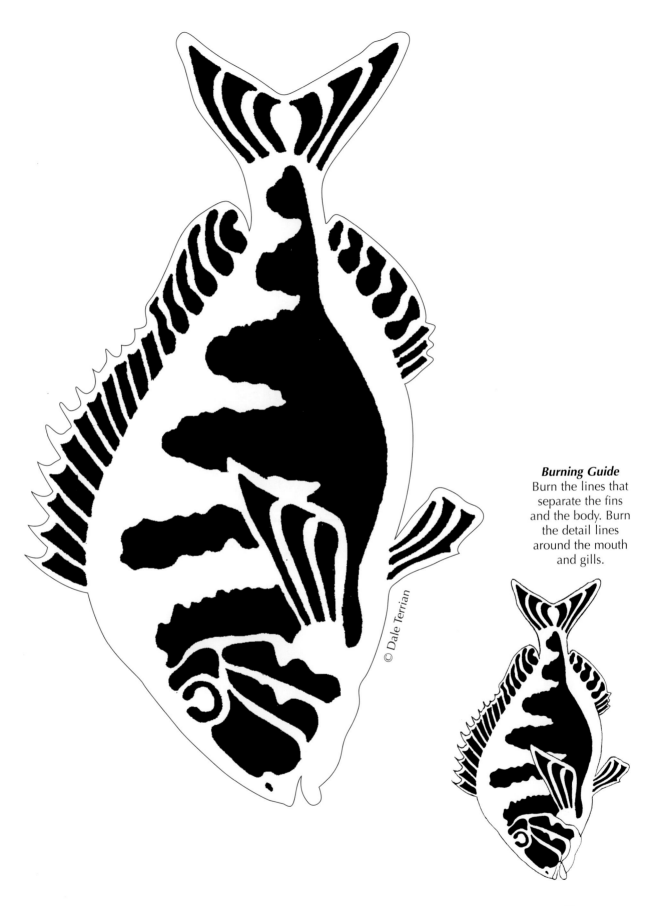

Burning Guide
Burn the lines that
separate the fins
and the body. Burn
the detail lines
around the mouth
and gills.

© Dale Terrian

White Bone Porgy

Marine Life Patterns for the Scroll Saw

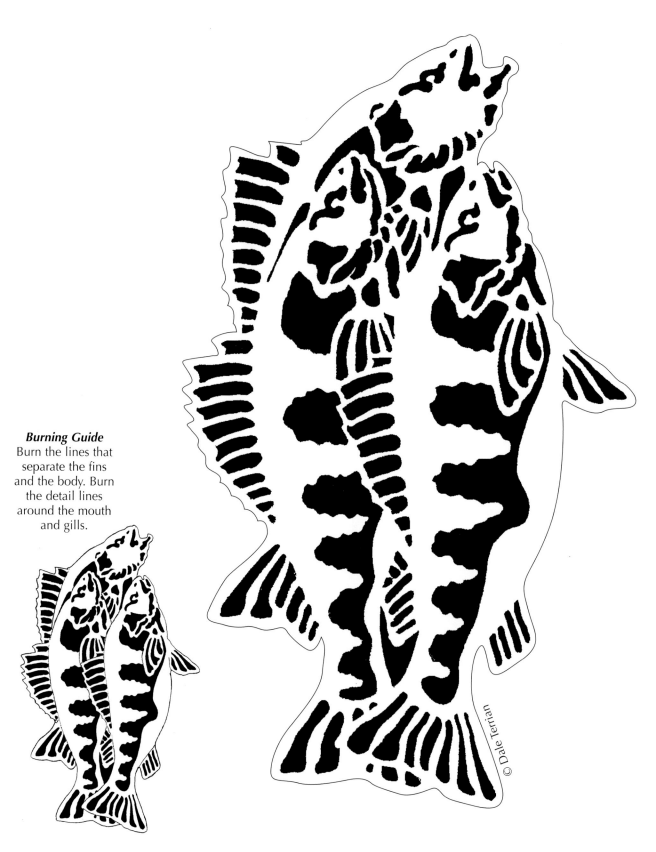

Burning Guide
Burn the lines that separate the fins and the body. Burn the detail lines around the mouth and gills.

© Dale Terrian

Yellow Perch

Marine Life Patterns for the Scroll Saw

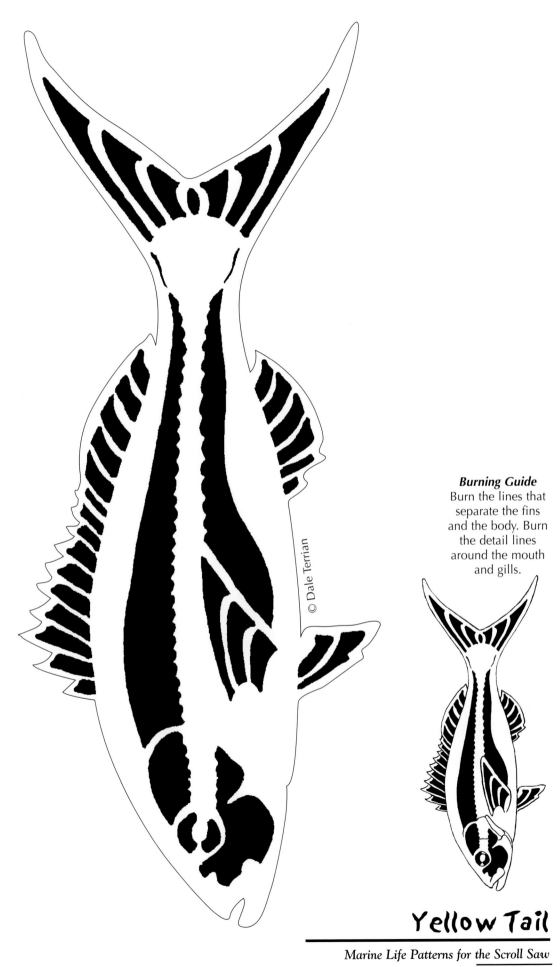

Burning Guide
Burn the lines that separate the fins and the body. Burn the detail lines around the mouth and gills.

© Dale Terrian

Yellow Tail

Marine Life Patterns for the Scroll Saw

SUBSCRIBE TODAY!

DON'T MISS ANOTHER ISSUE OF SCROLL SAW WORKSHOP

☐ **ONE YEAR** Subscription

☐ $19.95 USA
☐ $22.50 Canada - US Funds Only
☐ $27.95 Int'l - US Funds Only

☐ **TWO YEAR** Subscription

☐ $39.90 USA
☐ $45.00 Canada - US Funds Only
☐ $55.90 Int'l - US Funds Only

Please allow 4-6 weeks for delivery

Four issues per year

☐ Bill Me ☐ Check/Money Order
☐ Visa, MC or Discover

Name on card _____
Exp. date _____ Telephone () _____
cardnumber ☐☐☐☐☐☐☐☐☐☐☐☐☐☐☐☐

Send To:

Name: _____
Address: _____

City: _____
State/Prov.: _____
Zip: _____
Telephone: _____ Country: _____

VISA MasterCard DISCOVER NOVUS **CFBN**

SCROLL SAW TOYS AND VEHICLES
A Complete Technique and Project Pattern Manual
By Stan Graves

FREE with a two-year paid subscription

Subscription order desk 888-840-8590

SUBSCRIBE TODAY!

DON'T MISS ANOTHER ISSUE OF WOOD CARVING ILLUSTRATED

☐ **ONE YEAR** Subscription

☐ $19.95 USA
☐ $22.50 Canada - US Funds Only
☐ $27.95 Int'l - US Funds Only

☐ **TWO YEAR** Subscription

☐ $39.90 USA
☐ $45.00 Canada - US Funds Only
☐ $55.90 Int'l - US Funds Only

Please allow 4-6 weeks for delivery

Four issues per year

☐ Bill Me ☐ Check/Money Order
☐ Visa, MC or Discover

Name on card _____
Exp. date _____ Telephone () _____
cardnumber ☐☐☐☐☐☐☐☐☐☐☐☐☐☐☐☐

Send To:

Name: _____
Address: _____

City: _____
State/Prov.: _____
Zip: _____
Telephone: _____ Country: _____

VISA MasterCard DISCOVER NOVUS **CFBN**

How to Carve Wood - over 500+ color photos
Power Carving MANUAL
A Special Edition from your friends at Wood Carving Illustrated Magazine
BIRD CARVING Step-by-Step
207 Bits & Burs for Carvers
Carving Gun Stocks
Sign Making
Most Complete Tool Reference Available

FREE with a two-year paid subscription

Subscription order desk: 888-506-6630

FREE BOOK CATALOG

YES! *I'd like a free catalog of your woodworking titles. Please place me on your mailing list and send me a copy right away.*

Previously purchased titles:

I'm particularly interested in: *(circle all that apply)* General Woodworking Woodcarving Scroll Sawing Cabinetmaking Nature Drawing

Suggestion box: I think Fox Chapel should do a book about:

Bonus: Give us your email address to receive free updates.

Send to:
Name: _____ Email Address: _____
Address: _____ City: _____
State/Prov.: _____
Telephone: _____ Country: _____ Zip: _____

**Visit us on the web at www.Foxchapelpublishing.com
or call us at 800-457-9112**

AFB00

From:_____

City: _____
State/Prov.:_____
Country: _____Zip:_____

Put Stamp
Here

The How-To Magazine for Scrollers

1970 Broad St.
East Petersburg PA 17520 USA

From:_____

City: _____
State/Prov.:_____
Country: _____Zip:_____

Put Stamp
Here

Wood Carving
I L L U S T R A T E D

1970 Broad St.
East Petersburg PA 17520 USA

From:_____

City: _____
State/Prov.:_____
Country: _____Zip:_____

Put Stamp
Here

Fox
Chapel Publishing Co. Inc.

Free Catalog Offer
1970 Broad St.
East Petersburg PA 17520 USA